IMAGES
of America

WESTWOOD

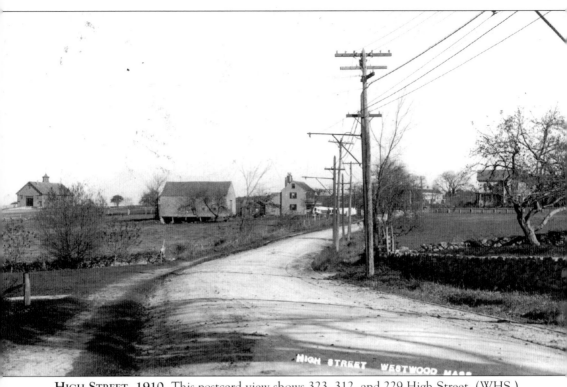

HIGH STREET, 1910. This postcard view shows 323, 312, and 229 High Street. (WHS.)

IMAGES
of America

WESTWOOD

Maureen A. Taylor

ARCADIA

Copyright © 2002 by Maureen A. Taylor.
ISBN 0-7385-1036-X

First printed in 2002.

Published by Arcadia Publishing,
an imprint of Tempus Publishing, Inc.
2A Cumberland Street
Charleston, SC 29401

Printed in Great Britain.

Library of Congress Catalog Card Number: 2002103806

For all general information contact Arcadia Publishing at:
Telephone 843-853-2070
Fax 843-853-0044
E-Mail sales@arcadiapublishing.com

For customer service and orders:
Toll-Free 1-888-313-2665

Visit us on the internet at http://www.arcadiapublishing.com

Contents

Acknowledgments 6

Introduction 7

1. Town 9

2. Schools 33

3. Churches 45

4. Business 55

5. Streets 71

6. Transportation 97

7. Town Life 107

8. Westwood in the Wars 117

9. The Westwood Historical Society 125

ACKNOWLEDGMENTS

There are many people to thank for their help with this book. I have not lived in Westwood my entire life and therefore did not have a full appreciation for the town's rich history before I began this project. The individuals who supplied material for this publication educated me about Westwood's history.

This book would simply not have been possible without the following people from the Westwood Historical Society: Lura Provost, Barbara Beale, Joan Swann, and Ralph Buonopane. Lura and Joan spent hours looking for photographs in the collections and editing captions with Barbara's assistance, and Ralph offered support and encouragement along the way. Some of the images in this book were taken by Ernie Greppin of the society, and John Pritchard volunteered to photograph objects from the society's collections.

Tom Viti and Margaret Reucroft, of the Westwood Public Library, offered assistance and the use of the library's large local history collection. Westwood residents are lucky to have such dedicated individuals. The library's vertical file contained an amazing amount of unpublished material.

Donors to the project were Off. Paul Sicard, of the Westwood Police Department; Lt. William Cannata, of the Westwood Fire Department; Barbara Magaletta; Charles Bean; Pastor Robert Davidson, of the Westwood Evangelical Free Church; Jan Kelley, of St. John's; Betsey Dakin, of the First Parish Church; Matt, of the Islington Barber Shop; Madeline Gregory; Elisha Lee; Genevieve Smith; Charles Rheault; Karen Brace; Gary Kellner; Helen McLaren; Susan Dyer; Anne Peavey Brown; Eric Arnold, of Hale Reservation; and Ronald Frazier and Peg Bradner, of the Dedham Historical Society.

Margaret Fenerty and Ernest Baker, now deceased town historians, left a written and photographic record of Westwood that is now in print in this publication. So much of this book is dependent on their work.

Those who contributed additional information and contacts for specific properties are Anthony McManus; Shirley Siroka, of Temple Beth David; Libby Johnson; Kathy Harding; and my great neighbors, William and Mary Brady.

Of course, I need to thank my family for their patience during the preparation of this book. My children, James and Sarah, now know more town historical trivia than they care to.

The following abbreviations are used in the photographic credits: DHS (Dedham Historical Society), WHS (Westwood Historical Society), and WPL (Westwood Public Library).

INTRODUCTION

Let us take a walk through Westwood at the end of the 19th century and see how the town has changed in a little more than 100 years. Prior to incorporation in 1898, the town was actually two villages (Westwood Center, known as West Dedham, and Islington, called Springvale until 1877). Both were divided by farmland but bore some similarities. Each part of town was situated on a major turnpike connecting them to larger communities—Islington with Walpole, South Dedham (now Norwood), and Dedham along Route 1; and West Dedham with Medfield and Dedham along High Street (Route 109). Transportation was either on foot, horseback, or stagecoach. The electric railway would not start running until 1899. Residents could take the train from the station on Carroll Avenue, in Springvale, to go to Boston or Dedham.

Each village contained a cluster of small family-owned businesses, such as dairy farms, blacksmith shops, butcher shops, and a thriving ice industry. These farms and small industries, run by the Bakers, Fishers, Ellises, and other families, began as offshoots of Dedham's population growth. The French Brothers, on High Street, supplied the residents of West Dedham with everything they needed from firewood to groceries. If they did not have it in stock, they ran a delivery service from Boston and Dedham stores to the people in town.

Students attended small one-room neighborhood schools, except for the classes held in the Colburn School (built in 1874). Each school contained elementary and middle school students and had a total population of less than 100 children. Older students took transportation to attend Dedham High School. One schoolchild, nine-year-old Granville Baker, started his own newspaper in 1896. *The Westwood Journal* appeared every other week, filled with news as reported to him from his father, William W. Baker.

As part of Dedham, town services were limited to four fire stations and a couple of elected constables. The library began as a small collection stored in Baker Hall, on High Street. The hall served as a local meeting place, school, and library—a central part of life in West Dedham. The post office in West Dedham was next to French's store in the Ellis Tavern. In Springvale, you could pick up your mail at the train station.

The citizens of each village knew each other. Their families went to school together, worshiped in one of the town's three churches (First Parish, Baptist, or Islington Community Church), and bought goods and services from local establishments.

By 1900, Westwood was an organized and growing community. The frequent runs of the electric trolley made it easy for people to travel from one town to another. To promote use of the trolley, the Norfolk Central Street Railway opened Westwood Park in the Brookfield Road

area on Washington Street. It offered visitors and residents a variety of entertainments, such as walking trails, amusement park rides, and shows featuring well-known entertainers.

In the mid-19th century, local philanthropists like Betsy Baker, the straw hat manufacturer, sponsored Irish immigrants and provided housing along High Rock Street to Hartford Street. Visionaries, such as Unitarian minister George E. Littlefield, established an experimental cooperative community, Fellowship Farm, off Oak Street. A housing boom in the 1930s and 1940s also brought new people to town to live in houses constructed by developer Perry Crouse in the Willow Farm area. Other population booms in the 20th century changed the look of many neighborhoods, such as Croft Regis.

This pictorial history of Westwood shows the contrasts and similarities between the town today and the town right before incorporation. So much history has been lost, from the houses that once lined major streets (now the site of small shopping districts and gas stations) to the farmland subdivided for housing. Many of the original families whose descendants built Westwood, with the exception of a small handful, no longer live in the area. The town's small industries have been replaced by larger companies or chain stores. Yet some things have stayed the same.

Today, more than 13,000 people call this community home. The majority of people travel by automobile, and the bus lines follow the old stagecoach and trolley routes. Trains now pick up commuters at Carroll Avenue, the Route 128 station, and the nearby Dedham Corporate stations. Our children once again attend neighborhood schools for elementary grades, followed by a central middle school and high school, both built in the 20th century. At 1,312, the current elementary school student population is a long way from the 100 pupils in the 1890s.

Unfortunately, much of Westwood's history is not well documented in pictures from public repositories, or it is hidden in private collections. Throughout this project, I searched for images at the Westwood Public Library, the Westwood Historical Society, and the Dedham Historical Society, as well as in family materials brought forward for inclusion. While there are more than 200 images in this book, there is so much of Westwood's history that was not photographed. For instance, where are the pictures of Islington when there were orchards, and what of the family farms and small businesses? Are there images of various organizational and town events, and if so, where are they?

This lack of photographic evidence is alarming when you realize that photography was introduced in 1839. During the more than 160 years since then, only a small number of pictures of the area are still in existence. Most of these were gathered by Ernest Baker for a slide show history of the town in the early 20th century.

If anyone has pictures or artifacts from Westwood, the Westwood Historical Society would love to hear from you. This small but vital organization has a state-of-the-art temperature- and humidity-controlled collection storage space at its Fisher School building on High Street.

As you look through the pictures gathered for this publication, think of the photographs you might take of the community as you know it. William MacLaren took numerous photographs of Westwood in 1952, and without those pictures, this book would be missing several landmarks that live in the memories of older residents—the Pond Plain Market, the Windmill, and the old High Street Market. Remember that history is in every passing moment, so take the time to preserve the history of your town with your camera before it is gone.

One

TOWN

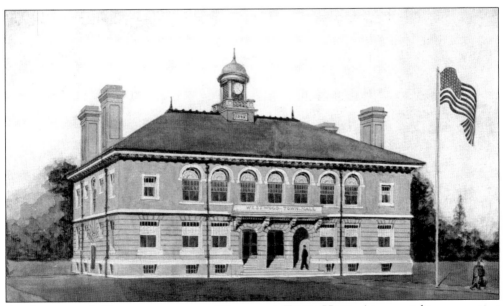

AN ARCHITECT'S RENDERING OF THE WESTWOOD TOWN HALL. At a special town meeting held on June 15, 1909, the citizens agreed to purchase land from Ethel Crane for a town hall. The new building, in the Classical Revival style of architecture, was designed by Stebbins and Watkins of Boston. Construction began in 1910 and was completed in the fall of 1911. (WPL.)

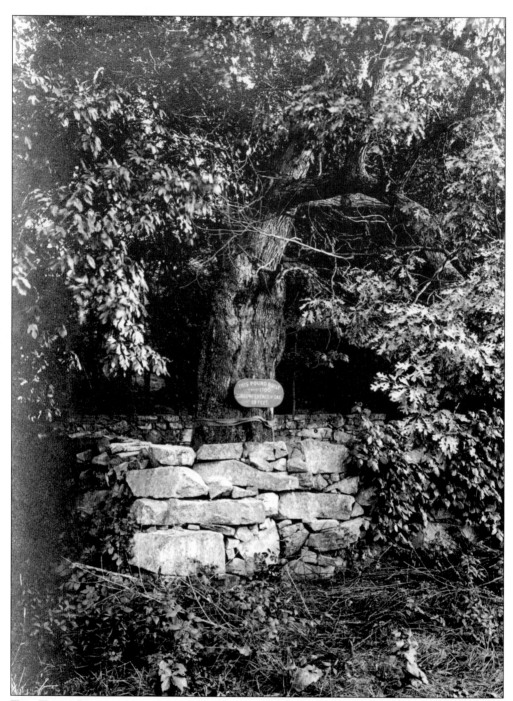

THE TOWN POUND, NEAR THE JUNCTION OF HIGH STREET AND ROUTE 128. Built by Lt. Joseph Colburn in 1700 on the first land grant "beyond ye rocks," the pound held stray animals until claimed by their owners. As the oldest Colonial town landmark, the pound appears on the Westwood town seal. The large oak tree in this picture was destroyed in the Hurricane of 1938. The site is now maintained by the keeper of the pound and the Westwood Historical Society. (DHS.)

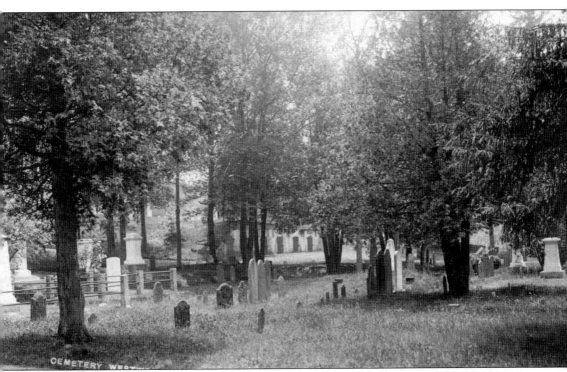

A Postcard View of Westwood Cemetery, High and Nahatan Streets, 1925. The community started the cemetery with land purchased from Nathaniel Kingsbury in 1752. Almost a century later, in 1843, the Unitarian and Baptist parishes held a fair to raise $1,100 to pay for a fence cast by the Benjamin Tubbs Iron Foundry (775 High Street). When the granite base was replaced in the mid-1990s, the original stones became the front steps of the Fisher School. Among the notable citizens buried here are John Buckmaster (first person buried, 1752), Betsey Baker (bonnet-making industry), Warren Colburn (educator), Robert Steele (Revolutionary War veteran), Samuel French (grocer), Henry Draper (ice dealer and farmer), Calvin Locke (minister of First Parish Church), Frank Very (astronomer), Charles Ellis (postmaster), Ernest Baker (town historian), Frederick Converse (composer), Henry Abel (blacksmith), and Ralph Lowell (founder of WGBH). (WPL.)

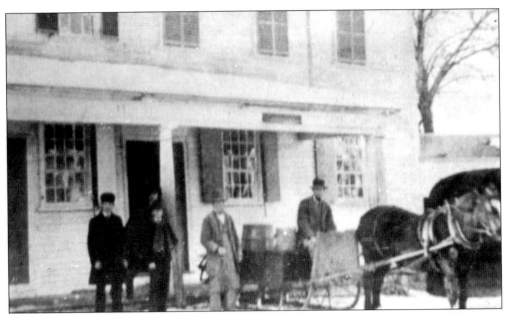

THE ELLIS TAVERN AND POST OFFICE, 1880. Local men wait for the daily mail delivery in this winter scene at the West Dedham Post Office. (WPL.)

THE WESTWOOD POST OFFICE, BEFORE 1937. Dedham established its first post office in 1795, and the mail was delivered to West Dedham either with residents or by stagecoach. By 1811, the Ellis Tavern was a formal mail stop. West Dedham's post office began in 1824 under Abner Ellis. The current post office on High Street was built in 1957. (WHS.)

A DAGUERREOTYPE OF THEODORE GAY II.
Appointed postmaster by Pres. John Tyler in
1845, Theodore Gay II remained in office
until his death in 1880. He was an uncle
to Charles H. Ellis, who succeeded him
in 1880. Together they served 90 years
as postmasters for the town. The Ellis
family actually held the position for
more than a century. (WPL.)

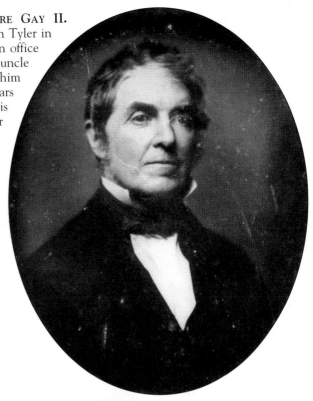

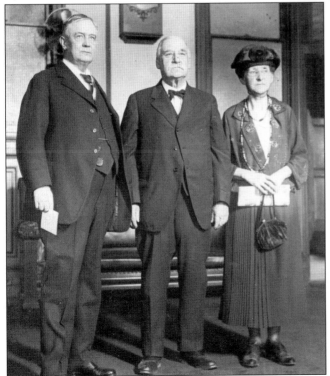

**CHARLES H. ELLIS (CENTER)
AND EMMA ELLIS WITH
POSTMASTER GENERAL
HENRY NEW ON A VISIT TO
WASHINGTON, D.C., 1924.**
When appointed, Ellis held
the distinction of being the
youngest postmaster in the
country. For 100 years, the
post office was in the same
location and operated by
three generations of the Ellis
family. Charles and Emma
Ellis were in Washington to
celebrate his holding the
office of postmaster longer
than any other person in the
United States. (WPL.)

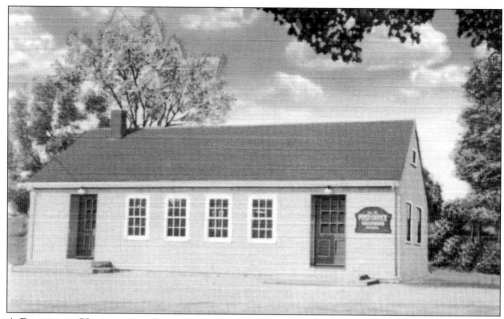

A Postcard View of the Post Office in Westwood. As the result of a need for additional space in 1937, a carriage shed was torn down on an adjacent lot for a new post office. This building served as the post office from July 1937 to July 1957. The original sign from this structure now hangs in the High Street post office. (WHS.)

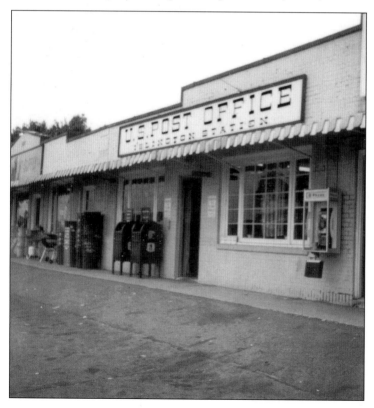

The U.S. Post Office, Islington Station. The original Islington post office (1873) was in Springvale Hall on Carroll Avenue. During several periods in its history, postal officials operated the office out of their homes. In 1892, the post office was in the Islington train station, which is no longer standing. (WPL.)

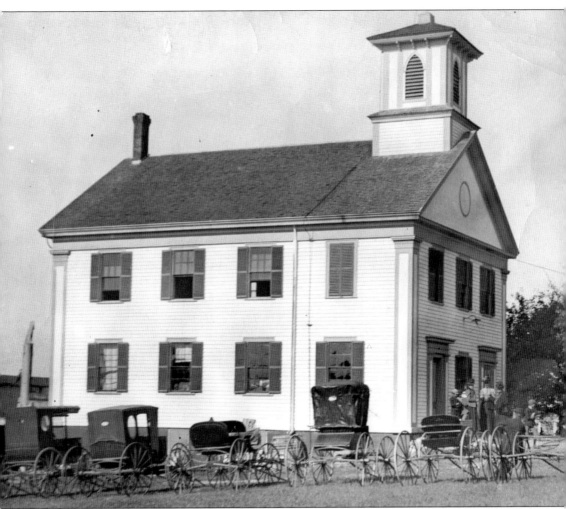

BAKER HALL, 649 HIGH STREET, 1900. Baker's Hall, a Greek Revival–style building built in 1847, has served several different purposes, such as the original Colburn School from 1847 to 1874; Westwood public hall from 1874 to 1897; Baker's Carriage Painting Shop in the basement; and the town hall from 1897 to 1911. In 1920, it was remodeled as a private dwelling. It became the Folsom, Smith, and Higgins Funeral Service in the 1950s. This photograph shows carriages parked on the grass and several people on the front steps on a summer day. (WHS.)

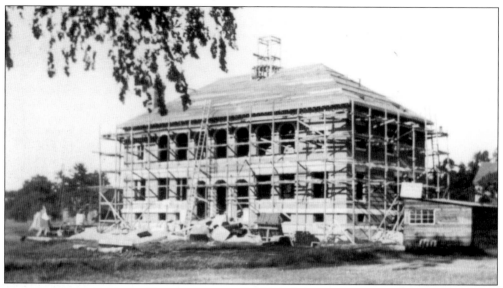

THE TOWN HALL UNDER CONSTRUCTION, 1910. A dedication ceremony on September 27, 1911, drew a crowd of 500 people to view its "spacious offices, banquet halls, vaults, dance floor, electric lighting system and modern sanitary facilities and steam heat." Offices were on the first floor, a stage was built on the second, and there was a jail in the basement. Rev. Calvin S. Locke said that the building stood for "order, justice, sociability, harmony, friendliness, fellowship and recreation." (WPL.)

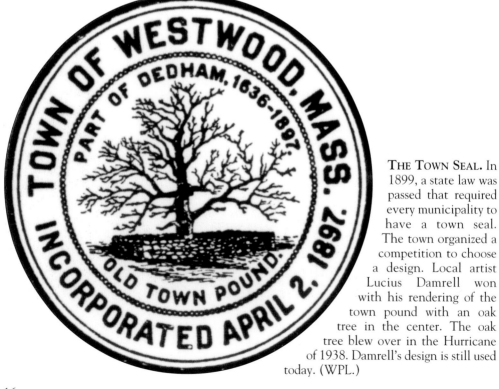

THE TOWN SEAL. In 1899, a state law was passed that required every municipality to have a town seal. The town organized a competition to choose a design. Local artist Lucius Damrell won with his rendering of the town pound with an oak tree in the center. The oak tree blew over in the Hurricane of 1938. Damrell's design is still used today. (WPL.)

16

THE WEST DEDHAM (WESTWOOD) AND DEDHAM ALMSHOUSE, FOX HILL STREET, 1890. Built in 1832, the almshouse served the needy until it was completely destroyed by fire on October 12, 1892. A small fire began in the barn and quickly spread to other buildings. George Lyman, superintendent at the time of the blaze, saved the furniture and the horses. Lyman, his wife, and 13 others were living there at the time of the fire. (WHS.)

THE TOWN FARM, 1920. A new almshouse, built in 1893 on the Joshua Crane Jr. farm on Fox Hill, had separate wings for men and women, with dining rooms, sitting rooms, a hospital room, and a bathroom. Each wing could house 14 people. In 1897, the town closed the facility due to a lack of residents, and it was sold in 1898. The house was then renovated to accommodate a single family. (WPL.)

A POSTCARD VIEW OF THE WESTWOOD PUBLIC LIBRARY, C. 1910. In 1840, the West Dedham library was established, but it was not until 1901 that the collection had a permanent home. This structure was built through a gift of Howard Colburn, with the stipulation that "any future buildings on the site should be for the same purpose." The present library was built on this site in 1956. (WHS.)

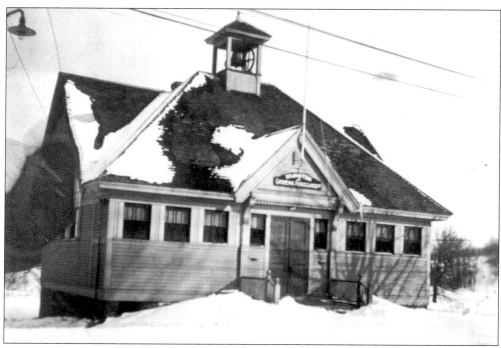

WENTWORTH HALL, WASHINGTON STREET. This building, constructed in 1884, was originally named for Judge Alonzo Wentworth, who donated the land. It was used as a school until the Islington School was constructed on School Street. A small structure at the rear housed a fire station; the bell in the tower was used for calling firemen. Today, it is the Islington branch of the Westwood Public Library. (WPL.)

FREDERICK FISHER, THE VILLAGE COP, 1909. Fisher was the first uniformed officer in the town. Each year, the town elected three constables for one-year terms. Fisher served Westwood as a constable and later as a police officer from 1899 to 1920. He lived in the Fisher House at 837 High Street. Other early constables were Isaac Carter and John Dean. (WPL.)

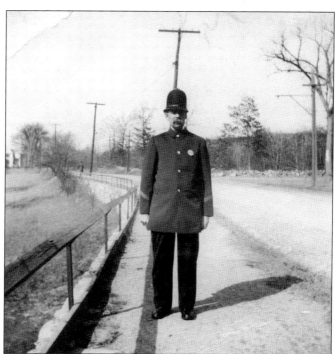

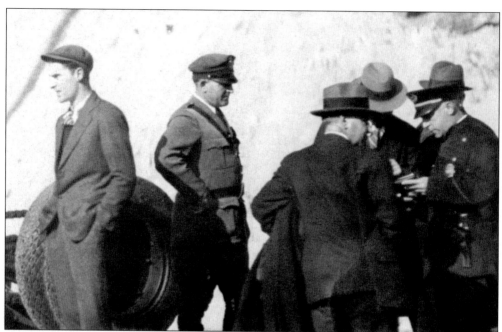

CHIEF PETER DRISCOLL AND MOTORCYCLE OFFICER AMELIO MAGALETTA, DECEMBER 31, 1931. Peter Driscoll was a special officer before he became chief in 1931. He left the force in 1933 to work at Westwood High School. Besides serving as a police officer, Amelio Magaletta flew stunt planes at Westwood Airport in the 1930s. In this view, the two officers are investigating an accident near the present-day Route 128 train station. (Westwood Police Department.)

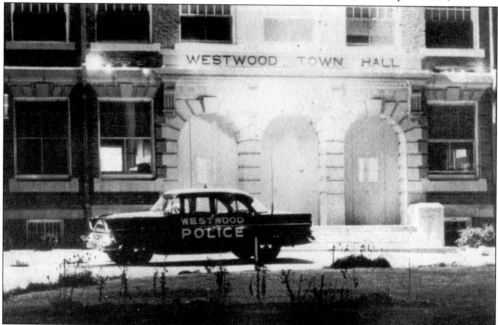

A POLICE CAR IN FRONT OF THE TOWN HALL, 1955. In 1931, the town organized a formal police force with headquarters in the town hall until the present police station was completed in 1967. (Westwood Police Department.)

WILLIAM SHEEHAN (1944–1975). On February 11, 1975, Off. William Sheehan and Off. Robert P. O'Donnell investigated a parked car on Canton Street and discovered Capt. John Oi shot. (The captain later died.) The gunman began firing at the two officers, killing Sheehan and injuring O'Donnell. The Sheehan School on Pond Street was named in honor of the deceased officer. (Westwood Police Department.)

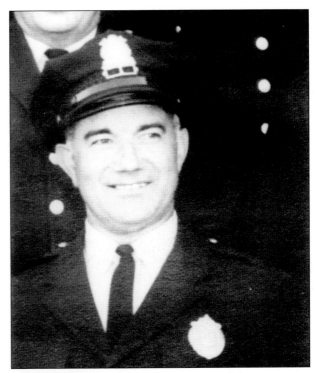

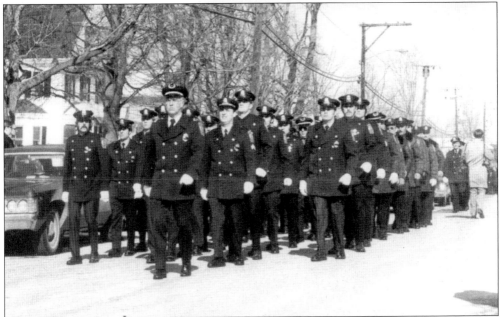

WILLIAM SHEEHAN'S FUNERAL, 1975. More than 3,000 police officers from four states attended Off. William Sheehan's funeral. Shortly after his death, the board of selectman retired Sheehan's badge (No. 1), established and awarded the William E. Sheehan Medal of Valor (posthumously given to Sheehan and awarded to Off. Robert P. O'Donnell), and created a Departmental Medal of Distinguished Service of Duty (given to Off. John McCarthy). (Westwood Police Department.)

GENEVIEVE SMITH AS A CROSSING GUARD. Genevieve "Jenny" Smith joined the Westwood Police Department as a school crossing guard in 1970, a position she still holds today. The department first hired women traffic supervisors as school crossing guards in 1955. Also shown in this photograph are Walter Poirer and Richard Hurley. (Genevieve Smith.)

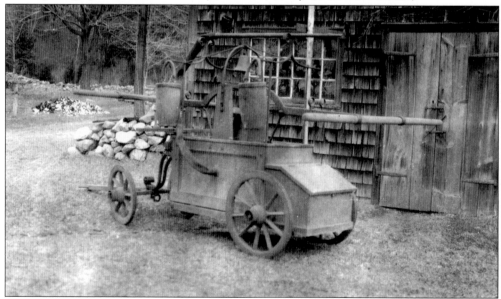

A HAND-PUMPED ENGINE. Six men were needed to operate this c. 1800 hand-pumped engine—three at the front and three at the rear. The hose was made of strips of leather, folded, glued, and riveted. The trunk, or chest, at the rear of the engine contained tools needed at fires. The town sold it in 1929 to the Henry Ford Museum in Dearborn, Michigan. (WPL.)

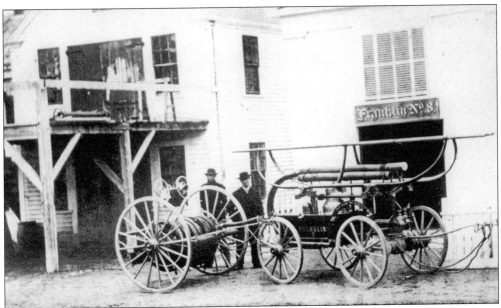

THE MEMBERS OF FRANKLIN COMPANY NO. 8, 1880. On November 9, 1846, the town appropriated $600 to buy land and build an engine house on High Street. Completed in 1847, it became the central firehouse and housed the hand-pumped engine. The Franklin Company was one of four stations in West Dedham, including Pond Plain, Wentworth School, and the Lion Company. (WPL.)

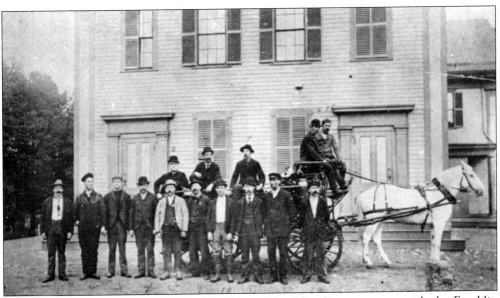

FRANKLIN COMPANY NO. 8, 1880. Members of Franklin Company pose with the Franklin Engine for which the station was named. In 1857, Dedham Company No. 8 decided to purchase a new engine. When it arrived, they passed out refreshments and hired a fifer and drummer. A year later, they competed against Washington Company No. 7 of South Dedham (now Norwood) for the best time filling the engine. Dedham won the contest. (WHS.)

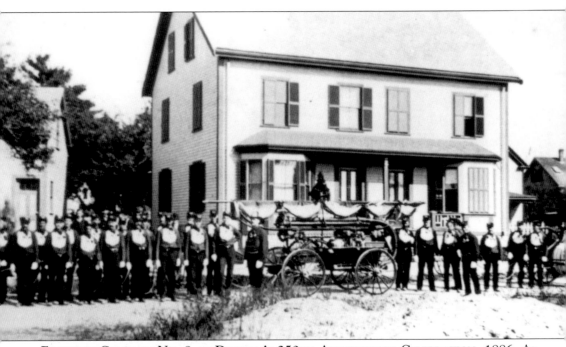

FRANKLIN COMPANY NO. 8 AT DEDHAM'S 250TH ANNIVERSARY CELEBRATION, 1886. At Dedham's 250th anniversary parade on September 21, 1886, the men of West Dedham's Franklin Company appeared in their uniforms of dark blue shirts, caps with white trim, gloves, and bibs. The bibs were inscribed with *No. 8.* Lion Company No. 2 also purchased uniforms consisting of a blouse and cap of white flannel with blue cuffs and collars. The company shield was on the shirtfront. Each member kept his own uniform and passed it on when he left the department. The 250th anniversary parade consisted of several sections. The fire department was in the second division, followed by schoolchildren, floats, and tradesmen. (WPL.)

WILLIE W. BAKER OF WEST DEDHAM. Willie W. Baker was Westwood's first town clerk, a position he held for 35 years. He also served as a member of the finance committee for one year, the school committee for 13 years, as the registrar of voters for 35 years, and with the fire department for 15 years. (DHS.)

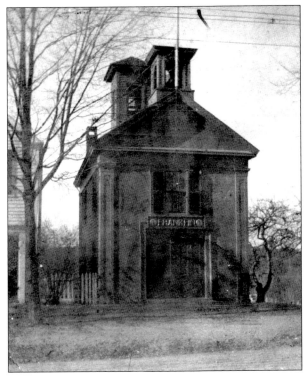

THE OLD FIREHOUSE ON HIGH STREET. This is a picture of the 1847 High Street Fire House. The single front door allowed access to the station's lone engine. (WPL.)

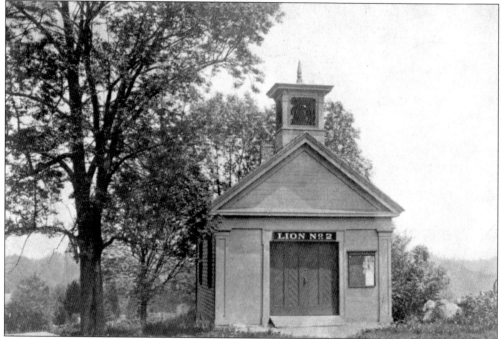

LION FIRE COMPANY NO. 2, CLAPBOARDTREE STREET, 1908. This was the original Lion Company fire station, which burned in 1910. It was one of four fire companies in town that used volunteers to fight fires. The Lion truck, for which the station was named, is still owned by the Westwood Fire Department. The sign is in the collection of the Westwood Historical Society. (WPL.)

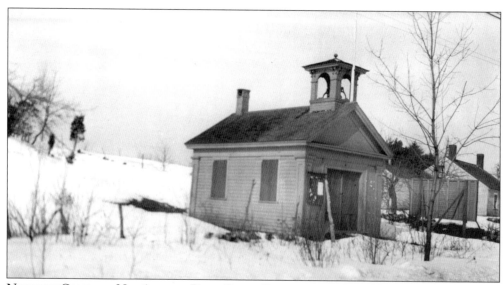

NORFOLK COMPANY NO. 6 IN THE POND PLAIN DISTRICT, C. 1923. This company disbanded in 1920, and a few years later, the engine house was destroyed by fire. The house in the background was near the site of 1325 High Street. The old hand-tub equipment was sold at an auction and is now in a private collection. (WPL.)

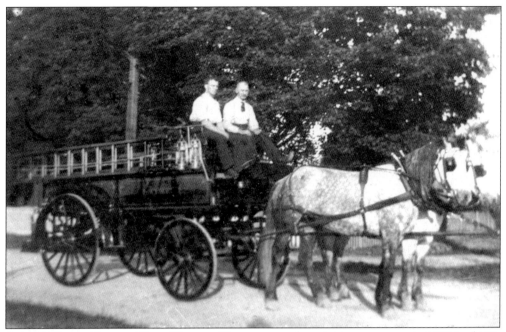

A 1909 HORSE-DRAWN HOSE WAGON. The town purchased this new wagon in 1907 for $600. It was equipped with both 25- and 16-foot extension ladders, extinguishers, axes, and storage space for coats and supplies. Fire Chief Henry F. Mylod is driving in this picture. (WPL.)

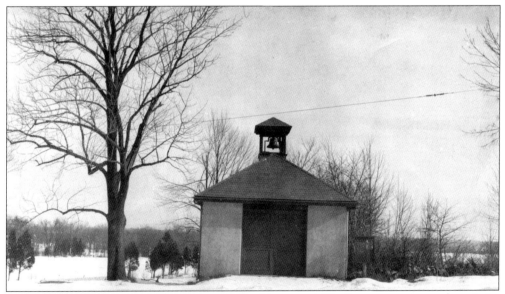

ENGINE HOUSE NO. 9. This unassuming building on Milk Street was once part of the Clapboard Trees No. 9 Fire Department. It housed the old bucket engine, Lion No. 2. The building, minus the bell tower, was built in 1910 as a replacement for the original station, which was destroyed by fire. (WPL.)

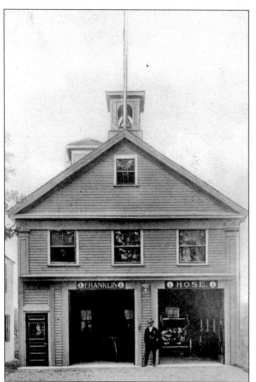

A POSTCARD VIEW OF THE WESTWOOD FIRE STATION (FRANKLIN COMPANY NO. 1), HIGH STREET, 1910. Enlarged and rebuilt in 1906, this station was used until a fire completely destroyed it on December 3, 1946. The cause of the blaze was an overheated furnace. The ancient Franklin engine and old hose wagon were saved, but a new forest fire tank truck and all other items of firefighting equipment were lost. (WPL.)

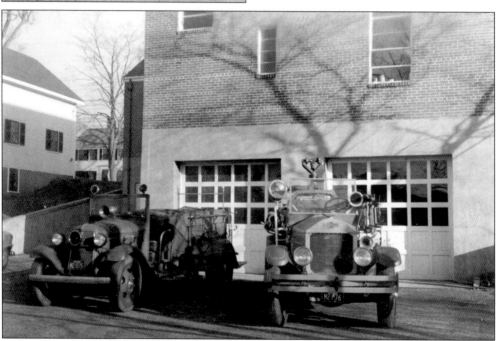

THE BACK OF THE CENTRAL FIRE STATION. This is a view of the back of the central fire station on High Street. The two vehicles shown are a 1934 Ford forest fire truck and a 1928 American LaFrance engine. These are no longer owned by the Westwood Fire Department. (Westwood Fire Department.)

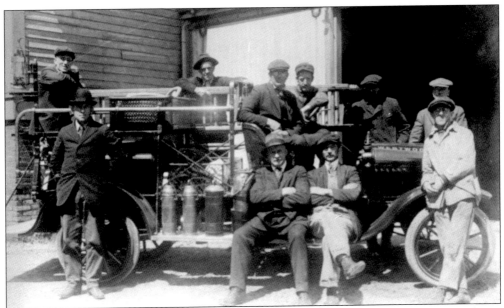

THE ISLINGTON VOLUNTEER FIRE DEPARTMENT, C. 1927. The department was housed in a small building at the rear of Wentworth Hall, now the Islington branch of the Westwood Public Library. From left to right are the following: (front row) John Fink, Albert Crocker, John Schaefer, and Adolph Fietz; (back row) Joseph Fietz, Perley Perham, Ralph Smith, Lewis Albrecht, Joseph Carpenter, and unidentified. (WHS.)

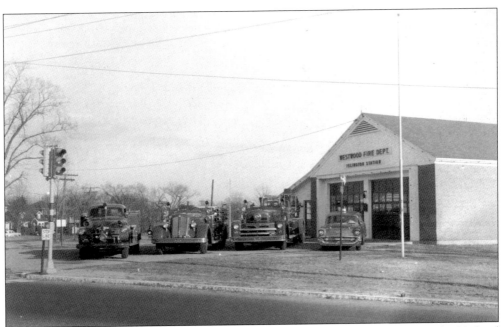

THE ISLINGTON STATION, 1956. The first Islington station, built in 1915, was in a shed behind Wentworth Hall (now the Islington Public Library). In 1942, the town erected a new station at the corner of East and Washington Streets. This picture shows the present-day station that was built in 1956 on the site of the Washington Street trolley carbarn. (Westwood Fire Department.)

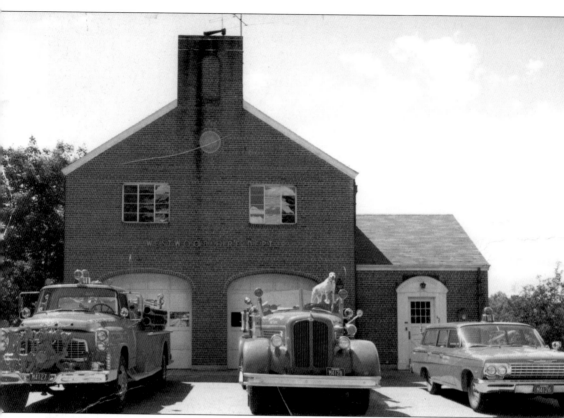

THE WESTWOOD FIRE STATION, HIGH STREET, 1964. In front of the station are the 1951 Seagrave, the International, and Chief Wiggins's car. This photograph was taken before renovations in the mid-1970s, when an addition was built. This station replaced the original firehouse, which burned in 1946. Notice Ember, the station mascot, on top of one of the trucks. (Westwood Fire Department.)

EMBER, THE FIRE DEPARTMENT MASCOT. This dalmatian was the mascot of the High Street station from the 1960s to the early 1970s. She loved to ride in the trucks but disliked going to fires. (Westwood Fire Department.)

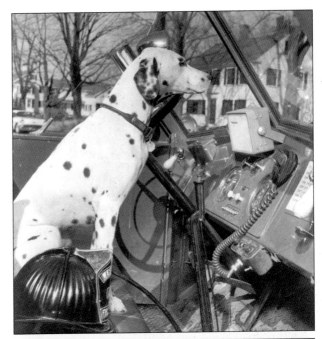

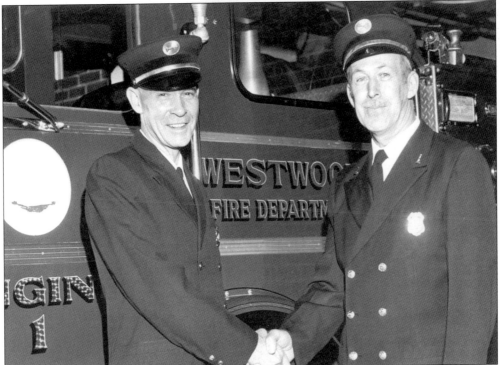

LT. CHARLES O. BRANN (LEFT) AND LT. THEODORE A. POTTER, C. 1971. Brann first served as a call firefighter before joining the department in 1956. He was promoted to lieutenant in 1971 and retired in 1981. Potter joined as a call firefighter in 1927 and served as the chief's aide from 1957 to 1963. He was promoted to lieutenant in 1963 and retired in 1971 after 44 years of service. (Westwood Fire Department.)

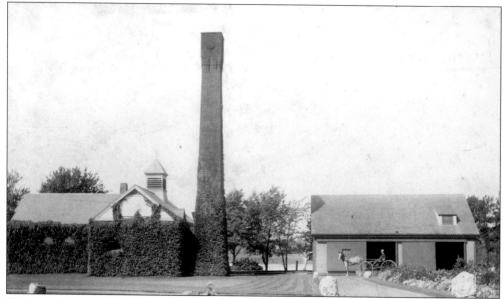

VIEWS OF THE PUMPING STATION ON BUCKMASTER POND, 1910. Buckmaster Pond, named for John Buckmaster, one of the original settlers of West Dedham, was used by residents in a variety of ways. The pumping station grounds were a popular spot for West Dedham residents because they were beautifully landscaped. For many years, the Baptist congregation used the pond for baptisms. In 1876, a group of Dedham citizens incorporated the Dedham Water Company with rights to take water from Buckmaster Pond. In 1885, Dedham awarded those rights to Norwood, infuriating the residents of West Dedham because it meant residents would be expected to pay higher taxes and could no longer use it for swimming. This action by Dedham was one of the factors in West Dedham's incorporation as a separate town. (WHS and WPL.)

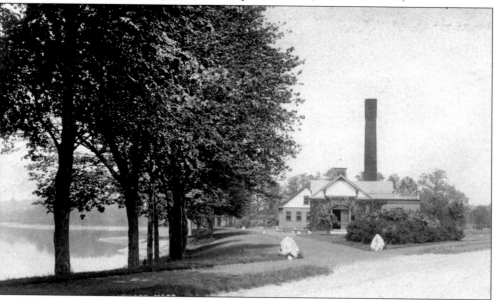

Two
SCHOOLS

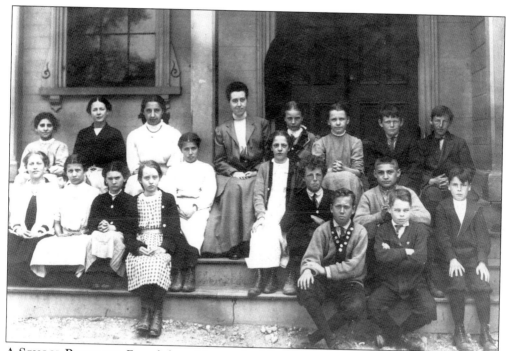

A SCHOOL PORTRAIT. From left to right are the following: (front row) Harriet Draper, Mildred Buckley, Mary B. Earner, Eleanor Very, unidentified, and Edmund Moclair; (middle row) unidentified, May George (Cox), Henry Hines, Henry Abel, and Everett Haley; (back row) unidentified, Katherine Hughes, Marie Magaletta, ? Fisher, Edith Venstrom, Sue Driscoll, Timothy Driscoll, and unidentified. (WPL.)

THE HOUSE AT 21 DOVER ROAD, 1920. The original 1774 Village School (District 8) occupied land leased by Abner Ellis next to the Ellis Tavern. When a new school was built in 1847, the building was auctioned off in three pieces. The side ell of this house was once part of the original school. It was added to the house by either James Colburn or Woods Parker. The other two pieces became part of 19 High Rock and 1284 High Street. (WPL and WHS.)

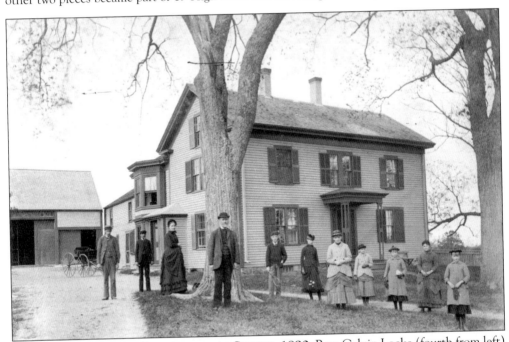

THE LOCKE HOME, 438 CLAPBOARDTREE STREET, 1890. Rev. Calvin Locke (fourth from left) and his wife (third from left) ran the Family School of West Dedham from 1863 to 1886 at the rear of their home at 438 Clapboardtree Street. It was both a day and boarding school for students through the second year of high school. The house was once the home of Parson Thatcher, minister of the Clapboard Trees Parish from 1784 to 1812. (WHS.)

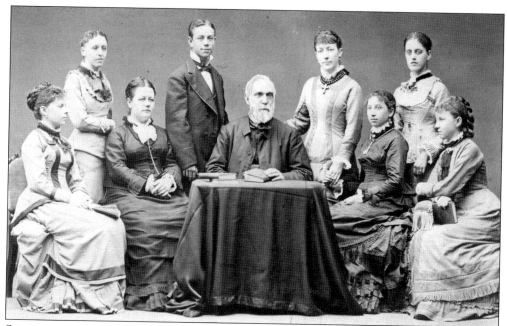

STUDENTS OF THE FAMILY SCHOOL OF WEST DEDHAM, C. 1880. This photograph shows Calvin Locke and his wife with students from their Family School of West Dedham. In addition to teaching, Locke was minister of the Unitarian church (1854 to 1863) and served the town on the school committee for nine years. He was also a library trustee for 15 years and gave the dedicatory remarks at the grand opening of the town hall. (WHS.)

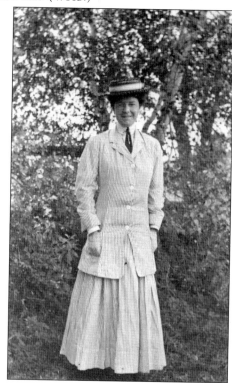

MARION FISHER, C. 1910. Born and raised in West Dedham, in a house on the site of St. Margaret Mary's on High Street, Marion Fisher taught at the Fisher School (1904 and 1905) and, later, at the Colburn School (1910). After leaving the Colburn School, she went to college for an advanced degree. She became principal of the Colburn School in 1914, holding the position until retirement in 1943. (WPL.)

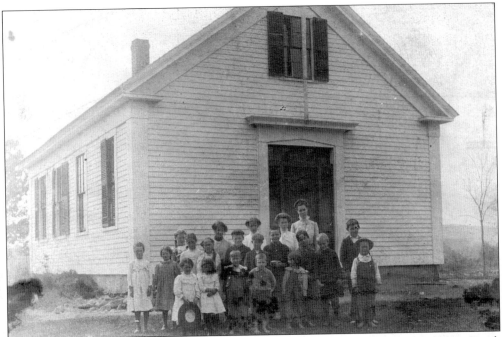

A Class at the Bubbling Brook School. This is an unidentified class at Bubbling Brook School. As a one-room school, it served between 8 and 12 pupils from elementary grades. (WPL.)

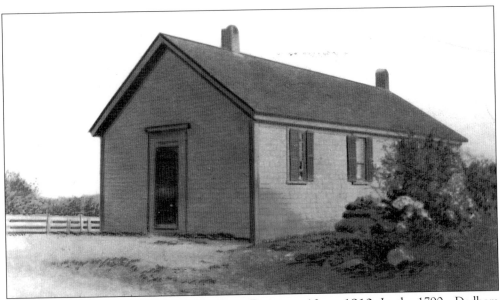

The Bubbling Brook School in Dedham District 10, c. 1910. In the 1790s, Dedham established this school in a building near the site of the Bubbling Brook restaurant at High and North Streets. It was also known as the Walpole Corner and Union school. Students came from Dedham, Walpole, and Dover. This building burned in 1893. (WPL.)

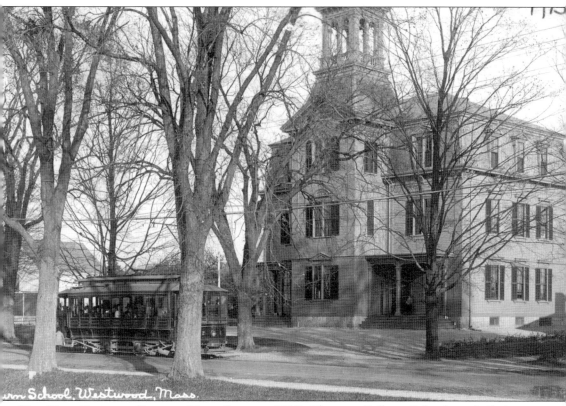

School, Westwood, Mass.

THE NEW COLBURN SCHOOL, HIGH STREET, 1915. The new Colburn School was built in 1874 and named for local residents Warren and Dana Colburn, known for their educational theories. The Victorian-style building sits on a foundation of granite stones and was originally roofed with slate shingles. Designed by Stebbins and Watkins, the school was considered to be "beautiful, convenient, and well-heated." The Italianate details include the mansard roof, the wide eaves with brackets, and the capped porch columns and pilasters. This new school had four classrooms and a large room for meetings and exhibits. Students in grades one through nine attended classes there. In the first town school census of 1899, there were three classrooms in Colburn, and the total school population was 89 boys and 98 girls between the ages of 5 and 15. By 1908, there were 124 boys and 106 girls attending Westwood Elementary and Middle School. High school students traveled to Dedham or Norwood. The Colburn School became the school administration building in the late 1950s. (WHS.)

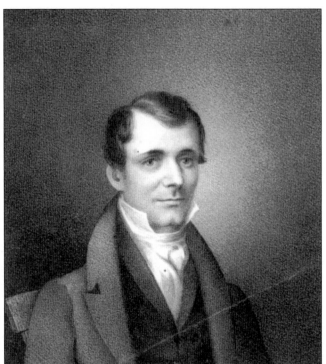

WARREN COLBURN (1793–1836). Warren Colburn attended Harvard University and developed a new method for teaching children mathematics called Intellectual Arithmetic. He wrote several widely used textbooks, including *Warren Colburn's First Lessons*, published by Houghton Mifflin. He later became the superintendent of the Lowell Public Schools. (DHS.)

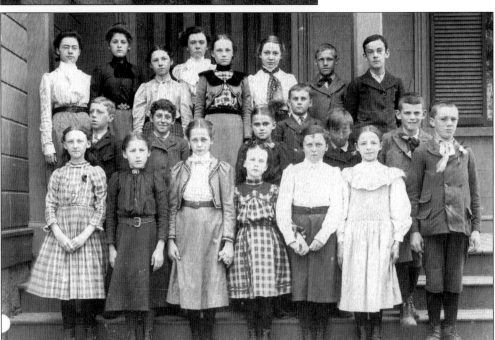

A PORTRAIT AT THE COLBURN SCHOOL, C. 1890. From left to right are the following: (front row) two unidentified students, May French, and four unidentified students; (middle row) Harold Baker, Joseph Baker, Grace Soule, unidentified, Howard Fisher, and unidentified; (back row) Carrie Mylod, Lillian French, unidentified, unidentified (teacher), Eleanor Fisher, Mabel Mylod, unidentified, and Granville Baker. (WPL.)

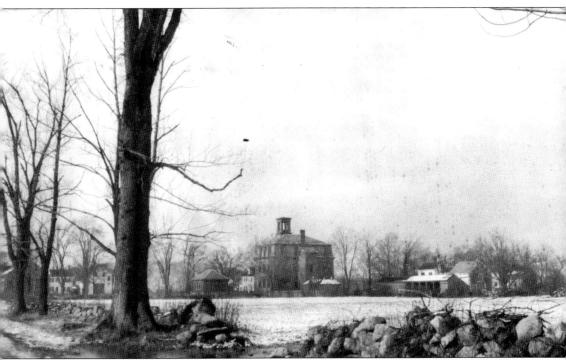

THE COLBURN SCHOOL, 1910. In this rear view of the town library and the Colburn School from Gay Street, the outbuildings are clearly visible. The wooden fire escape at the back of the building was replaced in 1936 by a metal one. In 1910, the Colburn School had just installed a force pump in the basement to supply students with drinking water. The school still had outdoor sanitary facilities; indoor plumbing would not be installed until the 1930s. There were 127 students attending the school. This photograph was probably taken from the corner of Fox Hill Street. (WPL.)

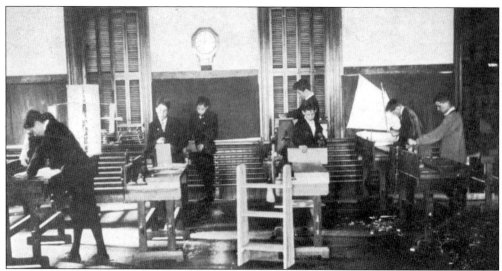

STUDENTS WORKING AT CARPENTRY BENCHES IN THE COLBURN SCHOOL, 1911. Students were taught manual arts, including woodworking, sewing, metalry, and stenciling for a class session each week with teacher Leah Curtis. All the students displayed their classwork in June. The school arts motto was "I will try to make this piece of work my best." Curtis wrote that the "manual arts offer a remarkable field for character development." (WPL.)

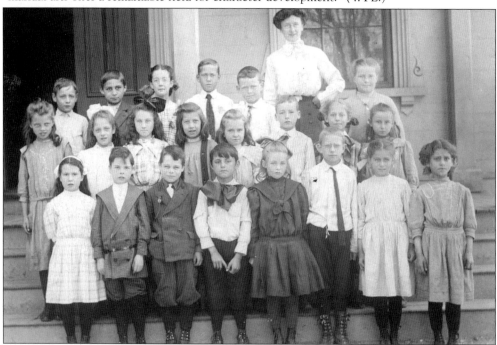

A THIRD- AND FOURTH-GRADE SCHOOL PORTRAIT, 1909. The teacher, posing in the back row in this photograph, is Franca Camp. From left to right are the following: (front row) unidentified, Everett Haley, Edmond Moclair, Leon de l'Etoile, and four unidentified students; (middle row) Lillian Venstrom, May George, ? Driscoll, three unidentified students, Harriet Draper, and unidentified; (back row) Joseph Abel, Henry Abel, Catherine Hughes, Edward Kelley, ? Driscoll, Franca Camp, and Bertha Haigh. (WPL.)

ANNIE JANET BARTON. Annie Janet Barton was a teacher at the Colburn School in the 1890s and later became the principal. Ernest Baker, town historian and a former student, remembered helping her take up the carpet, beat it, and retack it to the floor. (WPL.)

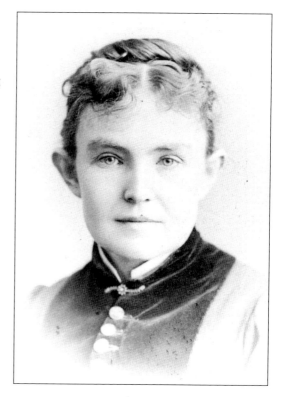

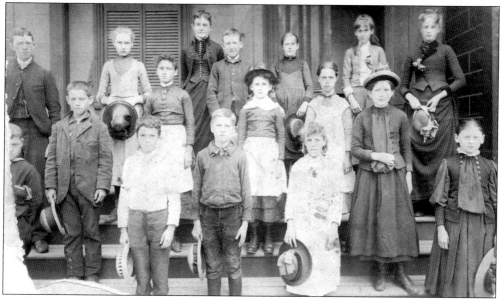

ANNIE JANET BARTON'S CLASS, C. 1890. Pictured from left to right are the following: (front row) Clarence Brown, Michael Sheehan, Jeremiah Sheehan, Ernest J. Baker, Carrie Maiers, Bridget Kenney, and Helena Seavey; (middle row) Mary Manning, Matilda Manning, and Irene B. Roby; (back row) Fred Thompson, Annie Mulvehill, Annie Janet Barton, Timothy Driscoll, Maria Soule, Alice Baker, and Lottie Price. (WPL.)

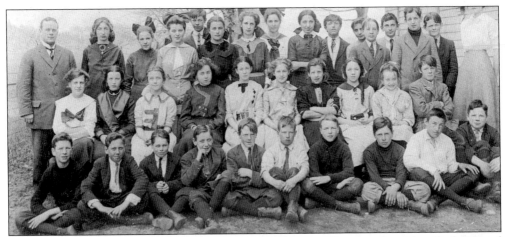

A CLASS FROM 1916. From left to right are the following: (front row) unidentified, Edward Kelley, Edmund Moclair, Joseph Abel, Lewis Maier, unidentified, Leon Ross, unidentified, Louis Perkins, and William Moclair; (middle row) Abbie Maier, ? Ross, Susan Driscoll, Alice Moclair, Catherine Hughes, Harriett Draper, Mildred Buckley, Louisa Chamberlain, unidentified, and unidentified; (back row) Fred E. Cargill (teacher), Irene Harris, Marietta Varnum, Amy Chamberlain, Harold Venstrom, Lillian de l'Etoile, unidentified, Rachel Jencks, Marie Magaletta, Lewis Wight, Henry Abel, unidentified, Robert Burns, Henry Draper, and Timothy Driscoll. (WPL.)

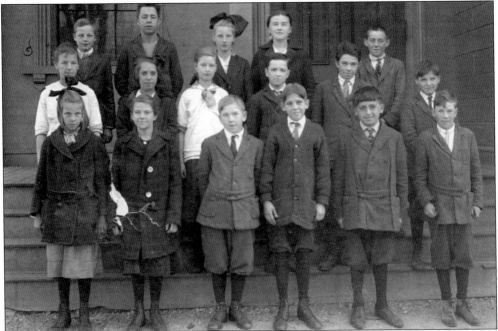

MARION FISHER'S CLASS, SEVENTH AND EIGHTH GRADES, 1917. These students are, from left to right, as follows: (front row) Evelyn Day, Esther Chamberlain, Edward Rogerson, Irving Schlusemeyer, Frank Magaletta, and Theodore Chamberlain; (middle row) Ruth Gorham, unidentified, Daisy Wells, Reginald Wakeman, George Chamberlain, and Walter Abel; (back row) Chester Venstrom, Ralph Jencks, Mildred Chamberlain, Viola Thompson, and Regge Scherer. (WPL.)

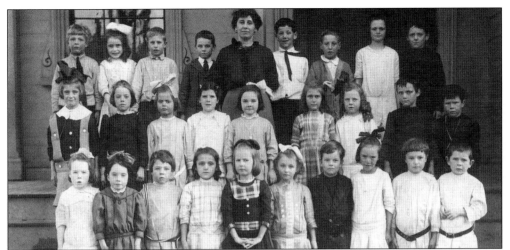

PRIMARY GRADES AT THE COLBURN SCHOOL, 1918–1919. The teacher shown is possibly Florence A. Baker, a graduate of the Bridgewater Normal School. There were 34 students in the first and second grades at the Colburn School that year, with an 88 percent attendance rate. (WHS.)

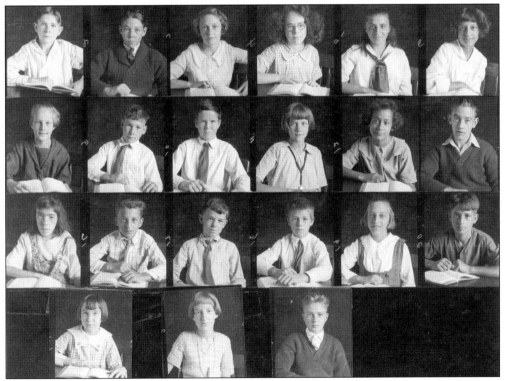

A COLBURN SCHOOL CLASS PORTRAIT. The teacher of this class was Marion Fisher. Her students are, from left to right, as follows: (first row) Roderick Morrison, Daniel Chamberlain, Mary Burke, Grace Moclair, ? Dubuc, and Nancy DeIaco; (second row) Vera Potter, Andrew Bain, George Deviney, Hazel Day, Camilla Paresi, and Edwin Parker; (third row) Lilly Bain, Irgill Dubuc, Clifford Baker, unidentified, Margaret Ward, and Alfred Magaletta; (fourth row) Charlotte Hayes, Mary Morrison, and Leslie Thompson. (WPL.)

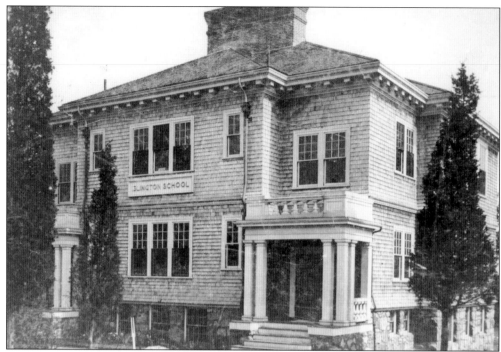

THE ISLINGTON SCHOOL, SCHOOL STREET. The Islington School was designed by Hurd and Gore as an elementary school in 1910, and an addition was added in 1937. Students loved the tin ceilings in each classroom. Each one was unique. This building replaced the Wentworth School, which is now the Islington Branch of the public library. The School Street playground is on the original site of the school, and the semicircular driveway is now the approach to the playground. (WPL.)

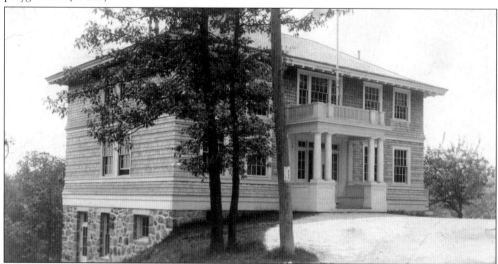

THE NORFOLK SCHOOL, HIGH STREET, 1910. In 1903, the Norfolk School Corporation, a group of men from Westwood and Dedham, purchased 12 acres near the Dedham line for construction of a private school. Four large rooms accommodated primary and kindergarten students. Operated as a school for more than a decade, it was converted to a residence by Westwood's tax collector, Louis Brooks, who maintained his office there. (WPL.)

Three

CHURCHES

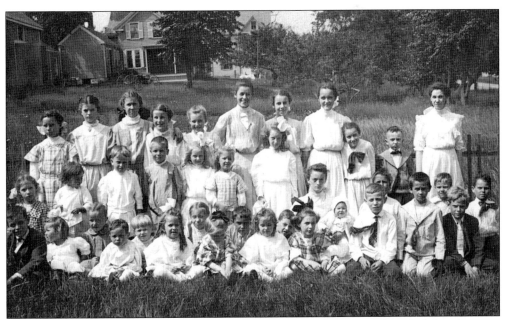

A Sunday School Picnic, June 17, 1909. This photograph of an unidentified church picnic is signed on the back, "To Mrs. Crummett because her Harry is in it." Known to be in the photograph are Marian Tolman, Helena Fietz, Hilda Parker, Esther Vietz, Florence Cook, Lillian Vietz, Albert Carr, Ebba Bloomstrom, and Eskil Boomstrom. (WHS.)

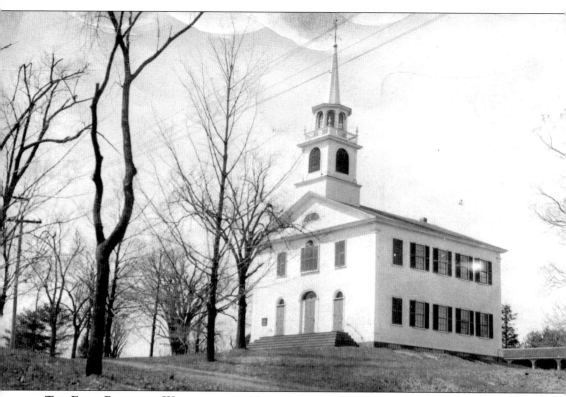

THE FIRST PARISH OF WESTWOOD, AT NAHATAN AND CLAPBOARDTREE STREETS, 1927. The First Parish of Westwood was organized in 1730 as the Clapboard Trees Parish, of the Congregational denomination. In 1736, Clapboard Trees Parish was also known as the Third, or West, Parish of Dedham. In 1898, this building became known as the First Parish of Westwood. In 1944, it was called the Federated Unitarian and Congregational parish. Again, in 1950, it was renamed the United Church. (WPL.)

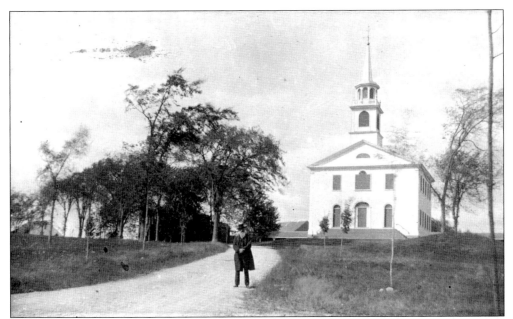

THE FIRST PARISH OF WESTWOOD. When this meetinghouse was built in 1809, the old timbers were auctioned off and eventually became part of the Baptist church. The original interior paneling ended up in houses around West Dedham. It is the oldest meetinghouse in continuous use in Norfolk County. (DHS.)

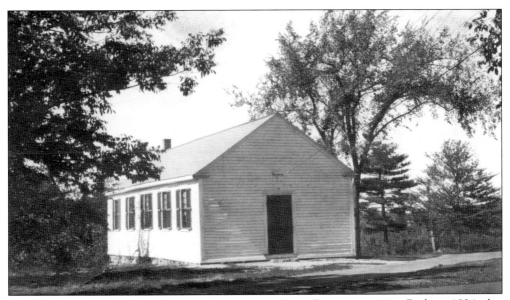

THE VESTRY OF THE FIRST BAPTIST SOCIETY OF WEST DEDHAM, 1920. Built in 1834, this structure served as a chapel, meeting room, Sunday school, and parish hall. For many years, the town hearse parked in the basement. Perry Crouse, developer of Willow Farm, purchased the house, moved it from its original location to Church Street, and remodeled it as a private home. (WPL.)

JAMES BRADFORD BAKER. James Bradford Baker was the organist at the Baptist church for more than 50 years. He owned a furniture factory on Mill Street that made cradles, beds, and coffins. He used to joke that he had Westwood residents covered "all the way." He died in 1895 at 85 years old. (WPL.)

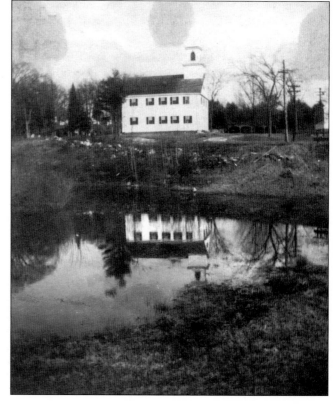

A VIEW OF THE BAPTIST CHURCH, 1896. This view shows the reflection of the Baptist church in Baker's Pond. While pastor of the First Baptist Church of Westwood from 1883 to 1886, Rev. Edward S. Ufford composed the words and music of the hymn "Throw Out the Life Line." It was first performed before a gathering at the corner of High and Hartford Streets. (WPL.)

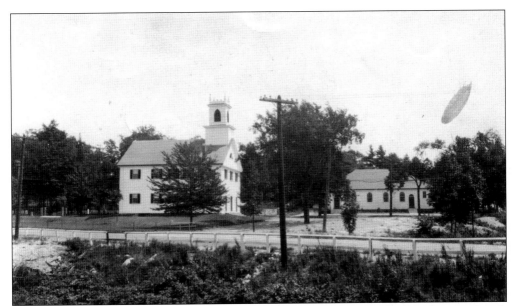

THE FIRST BAPTIST CHURCH IN A VIEW LOOKING SOUTH, 1925. The First Baptist church was built in 1809 with timbers from the old Clapboard Tree Parish church. An oxcart carried the wood downhill to the corner of Pond and High Streets. This view shows both the church and the parish house. (WHS.)

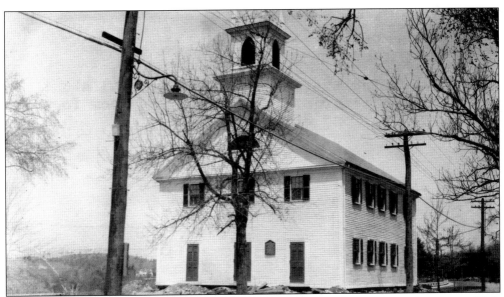

MOVING THE FIRST BAPTIST CHURCH, 1931. Before being moved to its current location on High Street, this church was moved several times on High and Pond Streets, its position being shifted on its lot to accommodate the widening of the streets. The most recent move brought the church closer to its new parish house at 808 High Street, providing parking for parishioners. (WPL.)

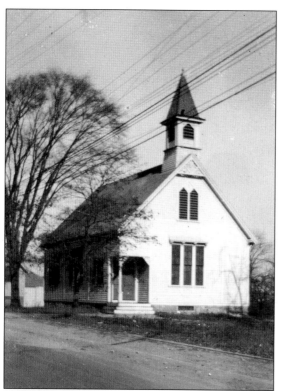

THE ISLINGTON COMMUNITY CHURCH, C. 1910. Originally located in Springvale Hall on Carroll Avenue in Islington, the Islington Community Church held its first services on December 21, 1873. The official church began when parishioners created the Balch Society of Springvale in Islington c. 1875. It was named for Rev. Thomas Balch, who once owned property in the area. In 1878, the Islington Congregational Church made plans to build a chapel. Judge Wentworth, who built Springvale Hall, donated land on the corner of East and Washington Streets. The view to the left shows the chapel when it faced south before East Street was relocated. The trolley tracks are on Washington Street, and the narrow path in front of the church is East Street. In March 1920, the church was turned to face Washington Street and enlarged. The old church was taken down in 1966 and replaced by a new edifice a year later. (WPL.)

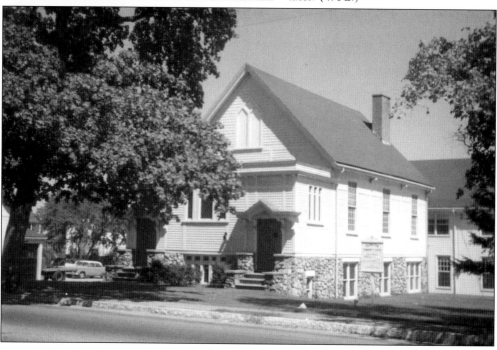

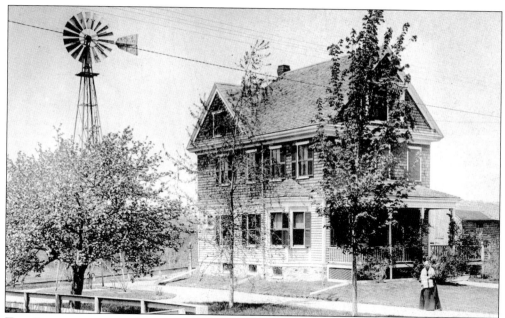

THE RECTORY OF THE CHURCH OF ST. MARGARET MARY, HIGH STREET, C. 1900. The owner, Mary Fisher Jackson, stands on the lawn on High Street. In 1934, Father Sullivan purchased the house for use as a rectory, along with four acres of land to build a church. The old woodshed served as a chapel until the church was finished. (WPL.)

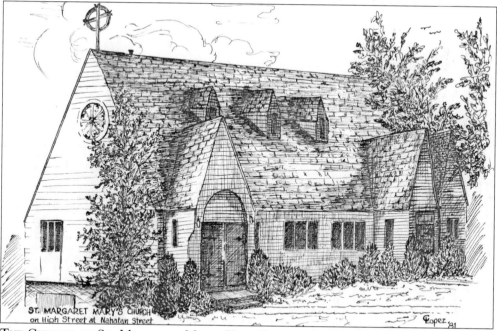

THE CHURCH OF ST. MARGARET MARY, HIGH STREET. Catholics in Westwood traveled to the surrounding communities of Dedham, Medfield, or Norwood for mass before the parish of St. Margaret Mary was established in 1931. Until their church opened on Easter Sunday 1936, masses were held at either Wentworth Hall or in the town hall. As the congregation grew, there was a need for a larger building. The current church was built in 1962. (St. Margaret Mary.)

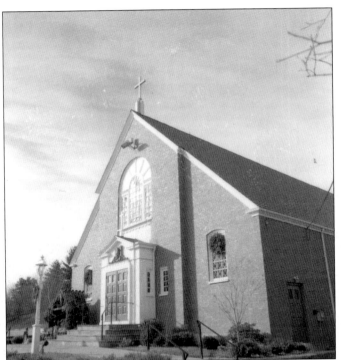

THE CHURCH OF ST. DENIS, WASHINGTON STREET. In 1940, Rev. Charles Dolan of St. Margaret Mary bought land from Fernald and Alice Spokesfield to build a new Catholic church to accommodate the growth in the town's population due to a housing boom. The church, designed by James Flaherty of the Charles Logue Company of Boston, is on the site of the Pineview Inn. The first mass was celebrated on Easter Sunday 1951. (WHS and Ernie Greppin.)

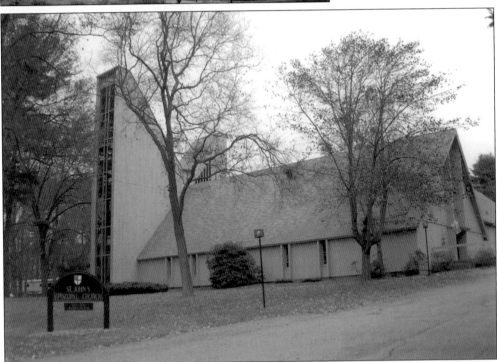

ST. JOHN'S EPISCOPAL CHURCH. Westwood's Episcopal residents attended church in Dedham until 1953, when St. John's Episcopal Church was built. The parsonage was at 144 Church Street until the present one was constructed in 1958. In 1965, an education and administration wing was added to the church. (Jan Kelley.)

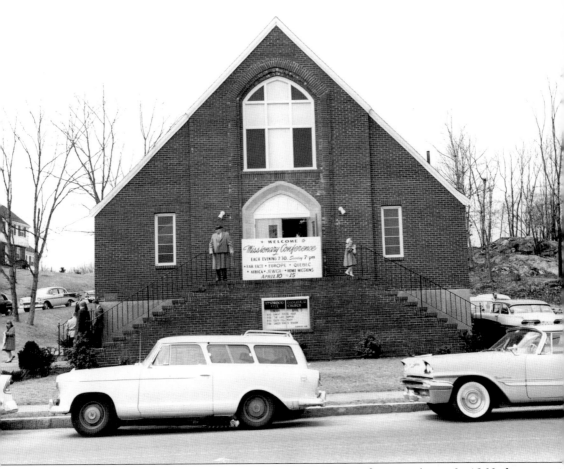

THE WESTWOOD EVANGELICAL FREE CHURCH, WASHINGTON STREET, APRIL 3, 1960. In 1884, a group of Norwegian immigrants established a Norwegian Christian Church in Roxbury, where Rev. S.K. Didriksen served as the first minister. As church members began to move to the suburbs, a committee met to decide on relocation. The congregation purchased property on Washington Street in 1953 for their parsonage, which was moved from Washington Street in Norwood to Westwood. Church services were held at the Pine Hill School and then at the parsonage until the church building was finished in 1957. This is a view of the church before the addition of an educational wing (1962), a narthex and entrance (1979), and a steeple (1983). (Westwood Evangelical Free Church.)

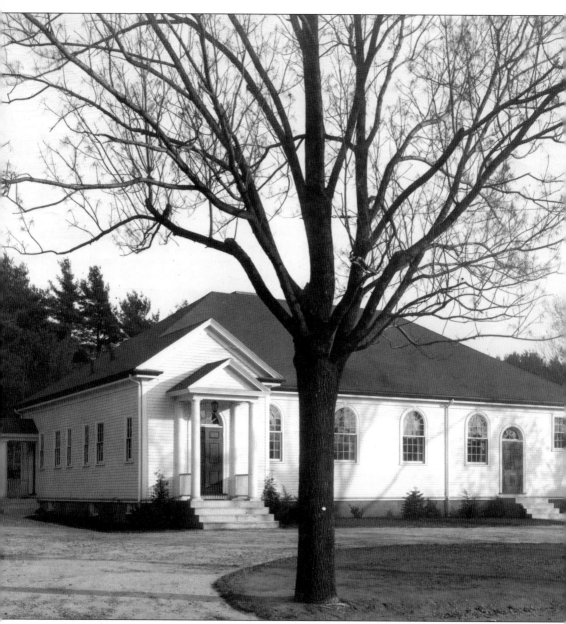

THE BAPTIST PARISH HOUSE, 40 POND STREET, 1932. This view shows the completed grounds, driveway, and landscaping when this building was the parish house for the Baptist Church. In 1967, Temple Beth David bought the property, and members of that congregation renovated the building to create a sanctuary and classrooms. Temple Beth David was founded by a group of Jewish families known as the Dedham Jewish Community. In 1961, they joined the Union of American Hebrew Congregations. In 1987, their new synagogue at the former Baptist parish house was destroyed by fire. Temple Beth David built a new synagogue at 7 Clapboardtree Street. The 40th anniversary of the congregation was in 2000. (WPL.)

Four
BUSINESS

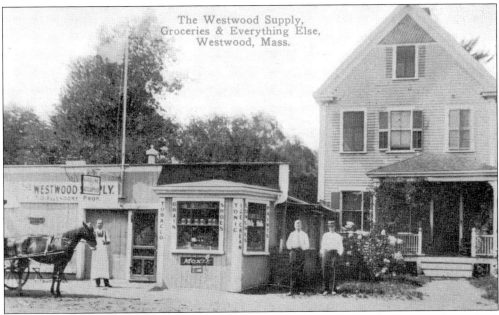

THE WESTWOOD SUPPLY STORE. This postcard shows Peter Allendorf's store, located on Washington Street near the corner of School Street. An inscription on the postcard brags that the store offered "groceries and everything else." (WHS.)

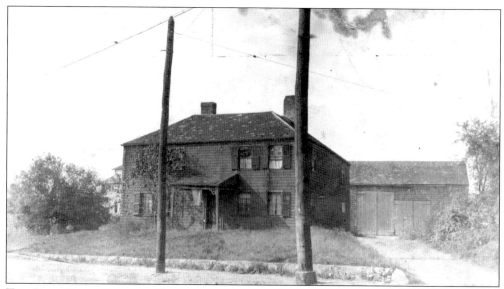

THE BLUE HART TAVERN, WASHINGTON STREET. In 1741, Jeremiah Dean operated the Blue Hart Tavern under a heart-shaped sign at the crossways of East Street and the King's Highway to Rhode Island. Today, this hip-roofed Colonial building is owned by the Magaletta family and retains many of its original architectural features. (WHS.)

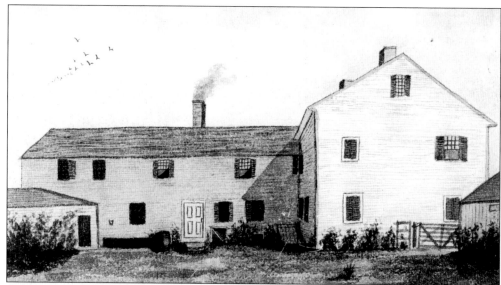

A SKETCH OF THE ELLIS TAVERN, 1886. This tavern, first established in 1732, had one large room on each of its two floors; the upper room served as a sleeping room for travelers. The long building in this drawing was the original tavern. It served as the meeting place for the West Dedham Sons of Liberty during the American Revolution. It was destroyed by fire in 1887 and was later rebuilt. (WPL.)

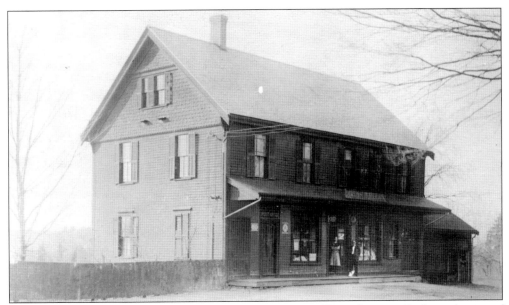

THE CHARLES ELLIS GROCERY STORE AND POST OFFICE, HIGH STREET. Built on the site of the original tavern after the fire of 1887, this building contained a general store and housed the post office until 1937. The West Dedham Library Club met here in the late 19th century. The Ellis buildings remained in the family for more than 200 years. This photograph shows the Ellis store and the adjacent post office after 1937. (WHS.)

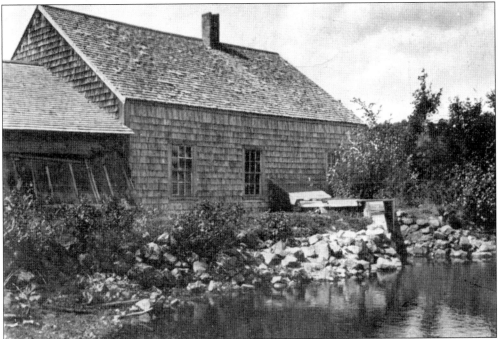

BAKER'S MILL, MILL BROOK POND. This mill, built in 1800, was once a sawmill. In 1851, it became Colburn's Cabinet Shop and, in 1876, James B. Baker's Kindling and Stove Wood Mill. Later, Baker opened a furniture shop where he made beds and coffins. Baker was the organist at the Baptist church and served as the village undertaker. (WPL.)

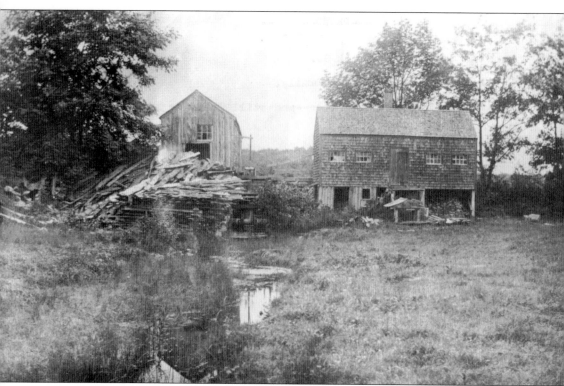

THE SAWMILL, 1886. James Pettee operated a sawmill at the junction of Bubbling and Mill Brooks from 1818 to 1851, until James P. Tisdale purchased it. Sawmills existed on this site as early as 1664, when settlers made the clapboards that lent their name to West Dedham's Clapboard Trees Parish. (WPL.)

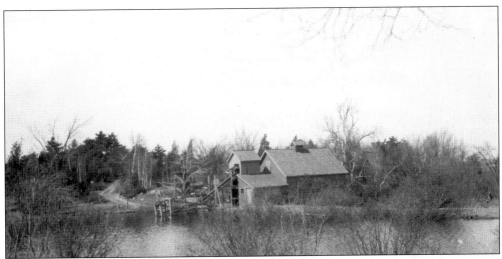

THE BUILDING ON LEE'S POND, OFF SUMMER STREET, 1923. Originally built as the Dedham Sugar Refinery in 1851, this building on Lee's Pond was later a sawmill and icehouse. Ice from this location kept dairy products cold in the summer during transport from West Dedham to market. In the 1930s, Lee's Pond was a popular recreation area with a boathouse. Between World War I and World War II, George Lee hired men to enlarge the pond. He offered them $1 per day and as much milk as they could drink from his dairy. (WPL.)

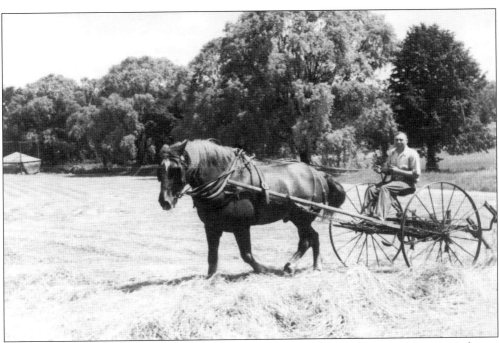

HAYING ON THE LEE ESTATE, JULY 1935. Lindsey Hale worked for George C. Lee at Hathorne Farm on Grove Street. Here he is on the hay mower. Crops were raised in the summer, and ice from Lee's Pond was harvested in the winter. (WPL.)

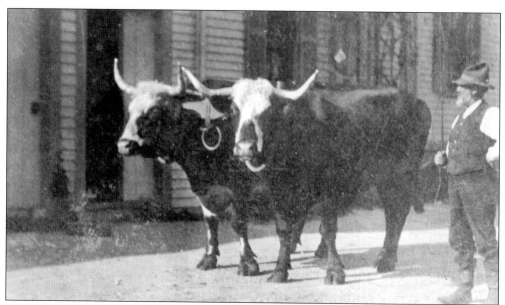

JOHN FISHER AND HIS OXEN, 1895. This photograph, taken at the corner of Gay and Fox Hill Streets, shows John Fisher leading his oxen to pasture. Fisher was just one of many milk dealers in West Dedham in the late 19th century. He was one of the first men to install electricity into his home at 375 Fox Hill Street. (WHS.)

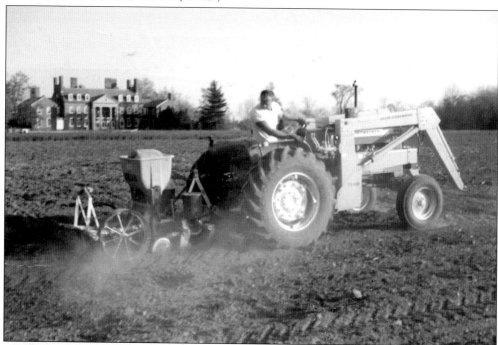

THE BEAN FARM, 1965. Charles Bean II is plowing the fields for planting Northern Belle corn with his 1965 Allis Chalmers tractor. The Malcolm Forbes mansion in Norwood is in the background. Bean picked 333 bushels of sweet corn per acre. Today, Bean Farm is the last farm left in town. It is a popular spot for families to buy pumpkins and fresh produce. (The Bean family.)

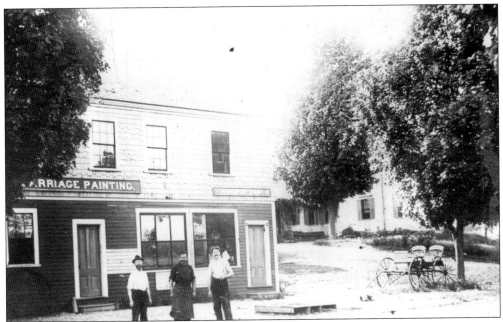

THE CARRIAGE-PAINTING SHOP IN ISLINGTON. In 1878, Jackson Lynas, a Scottish immigrant, set up his carriage-painting and harness shop next to the general store at the corner of Washington and School Streets. In 1897, he added a blacksmith shop. Today, it houses the Islington Barber Shop and other small businesses. (WPL.)

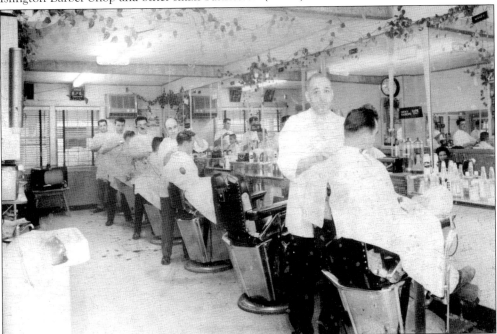

THE ISLINGTON BARBER SHOP, 291–295 WASHINGTON STREET. Now a commercial building, the Georgian-style saltbox was built c. 1880, probably by the Dean family. A blacksmith shop was added in 1897. Alfred Magaletta purchased the property in 1950, and his family still owns it today. (The Islington Barber Shop.)

THE DRAPER ICEHOUSE, 1923. This icehouse, located on north side of High Rock Street opposite the corner of Westchester Drive, was owned by Henry Draper. There was a pond on Rock Meadow Brook where ice was harvested for Charles Draper's dairy. The icehouse was torn down *c.* 1940. (WPL.)

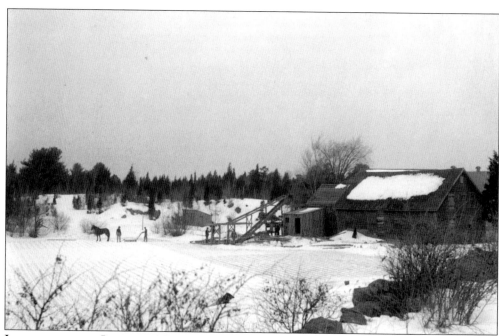

ICE HARVESTING, JANUARY 26, 1904. Ice was harvested before the January thaw, and horse-drawn plows pulled knives through the ice to cut it into blocks. The ice was stored in hay to preserve it during the warmer months. Buckmaster Pond, High Rock, and the Summer Street ponds were used for this industry. (DHS.)

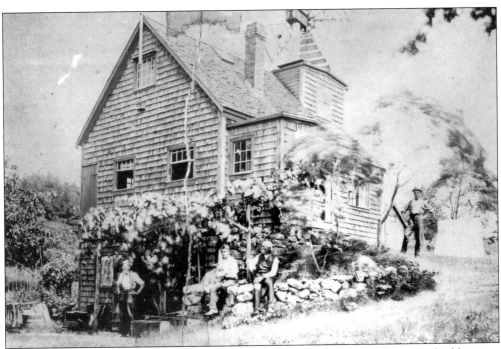

THE OLD GLOVER MILL, 65 MILL STREET, 1890. Built early in the 1800s, this building was first a blacksmith shop and later a small mill where the Glovers made cranberry rakes, nail sets, screwdrivers, and other tools. This windmill powered the shop until replaced by a gas engine c. 1905. The structure was torn down in 1940. Many implements manufactured at this mill are in the collection of the Westwood Historical Society. (WPL.)

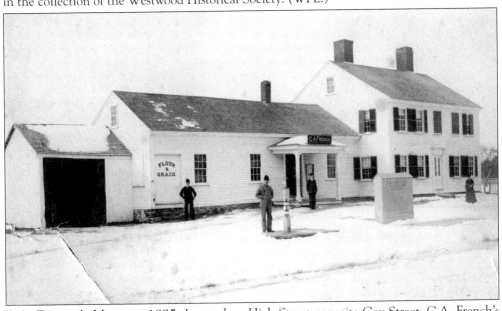

C.A. FRENCH'S MARKET, 1895. Located on High Street opposite Gay Street, C.A. French's Market carried wood, coal, and loose hay and offered a delivery service. The town scales for weighing products were in the front of the store. The Unitarian parish hall was later built on an adjoining lot. (WHS.)

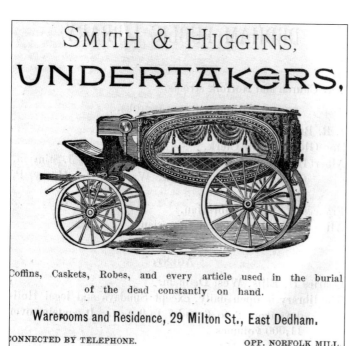

SMITH & HIGGINS,
UNDERTAKERS,

Coffins, Caskets, Robes, and every article used in the burial of the dead constantly on hand.

Warerooms and Residence, 29 Milton St., East Dedham.

CONNECTED BY TELEPHONE. OPP. NORFOLK MILL.

AN ADVERTISEMENT FOR SMITH AND HIGGINS, THE TOWN UNDERTAKERS. In 1899, the selectmen appointed Smith and Higgins as undertakers for the town. A telephone located at French's store connected them to potential business. They advertised in the Dedham directory and the *Westwood Journal* that they carried "every article used in the burial of the dead constantly on hand." Today, Folsom, Smith, and Higgins is located on High Street. (WPL.)

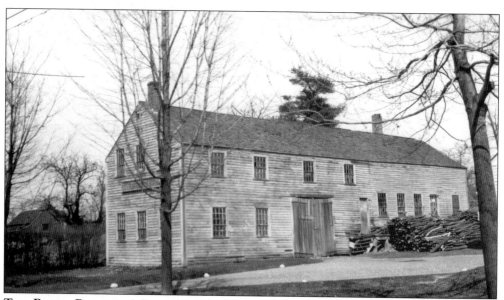

THE BAKER BROTHERS' PAINT SHOP, 1923. Charles, Richmond, Aaron W., and Edwin Whiting Baker all worked for their father, Samuel, in his paint shop on High Street, located in the side yard of 738 High Street. The building was converted from Warren Covell's Hoop Skirt Factory, which had once been Luther Crocker's carriage-making shop. (WPL.)

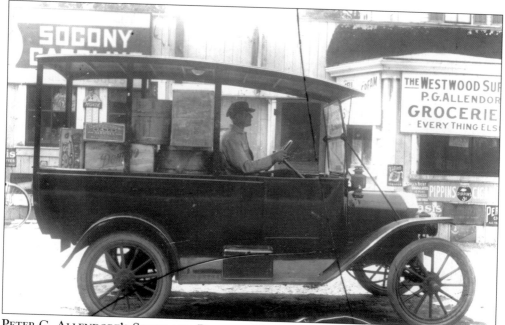

PETER G. ALLENDORF'S STORE AND DELIVERY TRUCK, C. 1925. Peter G. Allendorf operated a grocery store on Washington Street near Brookfield Road. According to the sign, he sold everything. Here he is driving the Model T Ford truck he designed for deliveries. Frank Schaefer was the original owner of the establishment. (WHS.)

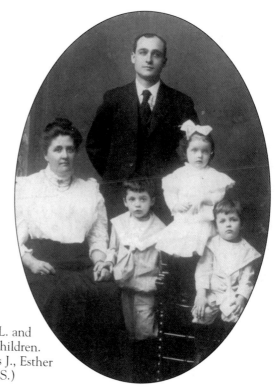

THE ALLENDORF FAMILY, C. 1910. Alice L. and Peter G. Allendorf are shown with their children. The children are, from left to right, Francis J., Esther M. (Cella), and George P. Allendorf. (WHS.)

65

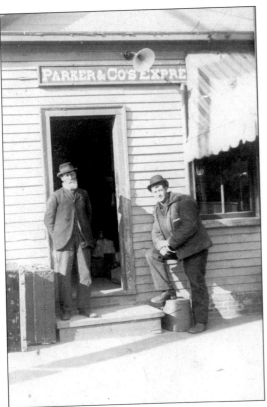

PARKER AND COMPANY'S EXPRESS. This was one of the delivery services that operated in Westwood. Parker's Dedham and Boston Express, under the proprietorship of Joseph L. Fisher, delivered items from Boston stores to Westwood and carried mail, newspapers, and passengers. (WHS.)

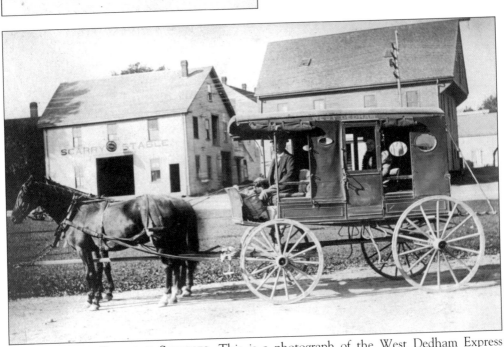

WEST DEDHAM DELIVERY SERVICES. This is a photograph of the West Dedham Express delivery service offered by French's store. Carrying packages and passengers between Westwood and Boston was a thriving business in the late 19th and early 20th centuries. (WHS.)

JOHN ABEL IN FRONT OF HIS BLACKSMITH SHOP ON HIGH STREET, C. 1910. John Abel, a German immigrant, came to Westwood in 1883. He started work in Francis Soule's blacksmith shop and eventually purchased it from Soule in 1887. There had been a blacksmith shop at that location since 1840. Abel's was originally located where the Mobil station is today. (WHS.)

THE ABEL FAMILY. Members of the Abel family are pictured in this 1920s image. Although their exact positions are not recorded on the photograph, the men are identified as follows: (front row) Walter, John, and Edward; (back row) John Jr., Henry, Joseph, and George. (WHS.)

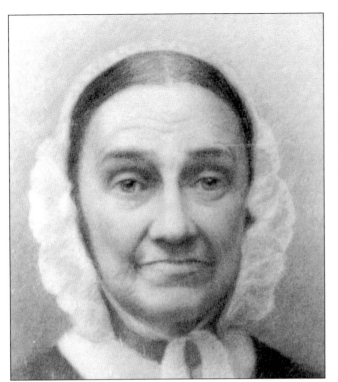

BETSEY (METCALF) BAKER (1786–1867). Betsey Metcalf moved to West Dedham from Providence when she married Obed Baker. In 1799, she began a bonnet-making industry. Once in Westwood, she continued making bonnets with the help of women in town and started the first Sunday school in the area at the Baptist church. Betsey was involved in charitable endeavors, including helping Irish immigrants establish themselves in West Dedham. She also sent money, food, and clothing to Ireland during the Famine. (WHS.)

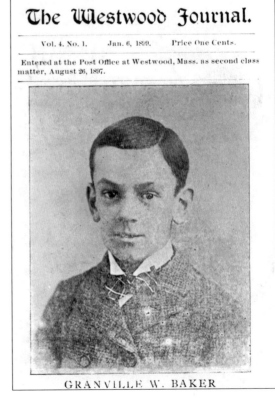

GRANVILLE W. BAKER, PROPRIETOR OF THE WESTWOOD JOURNAL. Granville W. Baker began publishing the paper in 1896, at the age of nine. A sickly boy, he could not attend school, so he gathered news from his father, Willie Baker, the town clerk. Baker printed each issue by hand until he bought a small printing press. He continued publishing the paper until he was well enough to attend Dedham High School in 1901. (WHS.)

THE POND PLAIN STORE, 1952. Edward Mahoney and his family ran this variety store at the corner of Pond Plain and Circuit Roads in the 1930s and 1940s. Many local residents remember stopping here for candy on their walk to the movie theater in Norwood Center. William McLaren took this photograph. (WHS.)

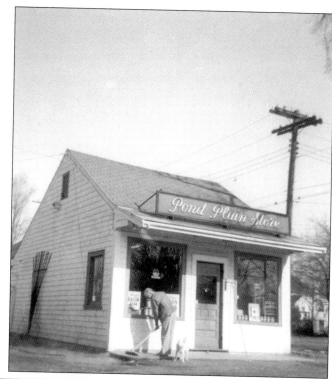

MCLAREN'S PRODUCE STAND, 312 HIGH STREET. Anthony McLaren grew produce—apples, pears, cherries, potatoes, and winter squash—to sell at this stand in front of his house. Both Anthony and his son William McLaren were well known for their service on the board of assessors. Anthony served for more than 45 years. This is a picture of Frederick P. Norris, who helped run the farm stand. McLaren's produce stand closed in 1952. (Helen McLaren.)

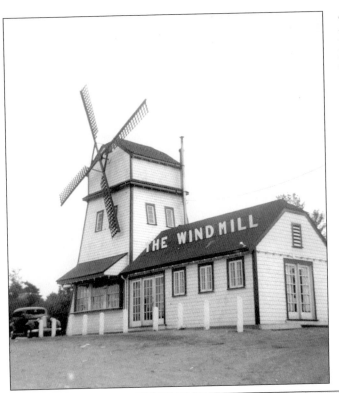

THE WINDMILL RESTAURANT, 1952. This popular ice-cream stand, owned by Vival Ingraham, once stood on East Street where the Meditech Company is located today. It was open from April to October, depending on the weather, and was a stop for Westwood High School students after the prom. When the establishment was torn down for Route 128, Ingraham purchased the Bubbling Brook Restaurant at High and North Streets. This photograph was taken by William McLaren. (WHS.)

THE HIGH STREET MARKET, 1952. The High Street Market sold groceries and meat. During World War II, many residents bought meat there. The post office block was built here in 1952, where the present-day High Street Market is located. (WHS.)

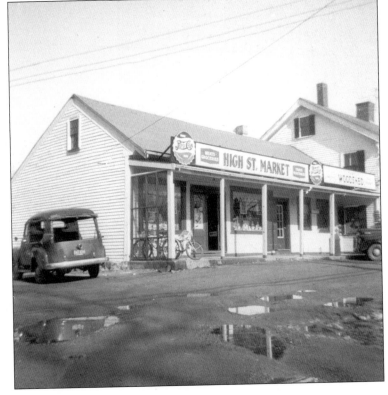

Five

STREETS

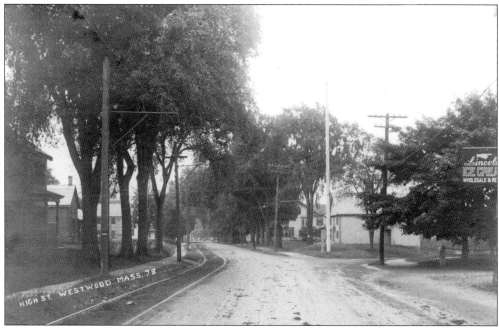

HIGH STREET AND THE RESERVOIR COMMON, C. 1915. This view, looking south from Gay Street, shows the junction of Hartford Street and the town flagpole. There was once a water reservoir under the common to be used in case of fire. The advertisement for Lincoln's Ice Cream is where George A. French's grocery store once stood. It is now the site of the post office. (WPL.)

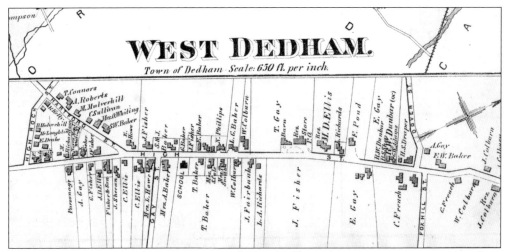

WEST DEDHAM, 1876. This is a segment of West Dedham, from J.B. Roger's *Map of Dedham* (1876), showing High Street and the connecting streets in the village. Each lot shows the approximate size and shape of lots and houses, along with the names of the owners. (WHS.)

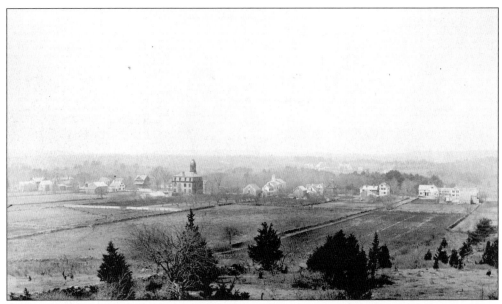

A VIEW OF WEST DEDHAM, OCTOBER 4, 1893. This view was taken by a Miss Sumner (later Mrs. A.B. Colburn) when she was a member of the Dedham Camera Club. It shows the field that extended between Fox Hill and High Streets. The Colburn School is the outstanding landmark on the left-hand side. Notice the stone walls dividing the property. (DHS.)

72

THE WEATHERBEE FARM, 240 CANTON STREET. The Weatherbee family built this house in 1790, on a 64-acre farm. The house and land remained in the family for almost 200 years. John E. and Henry Weatherbee were among the original signers of the incorporation of Westwood in 1898. In 1987 and 1988, the PBS program *This Old House* restored the property. (Ernie Greppin.)

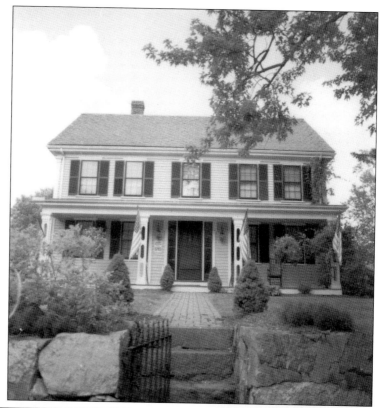

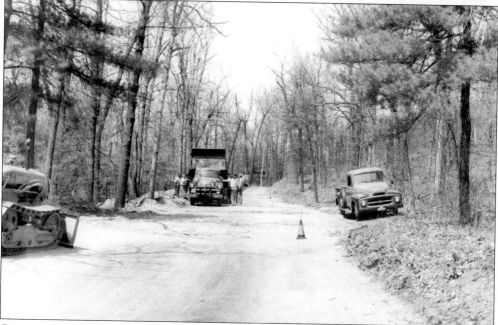

CANTON STREET, 1957. In 1957, many of the streets in Westwood were still unpaved. The highway department reported that it coated five miles of these streets that year. (Westwood Police Department.)

CARBY STREET, NEAR DOVER ROAD. This house once stood on a hill where the highway department garage is now. Both the hill and the house are now gone. It appeared on the 1876 map of the area by J.B. Rogers and was assessed for $200 in 1905. (WPL.)

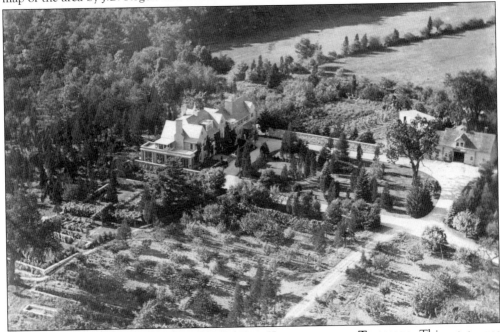

AN AERIAL VIEW OF 328 CLAPBOARD STREET, KNOWN AS THE TREETOPS. This estate was built in 1904 on the Joseph Onion estate by Ezra Child. It featured formal Italian gardens, a greenhouse, caretaker's lodge, and squash court. The land that was part of the first Clapboard Trees meetinghouse (1730) is part of the property. In 1920, Ezra Child married Edwin S. Dodge, and they continued to live here. (WPL.)

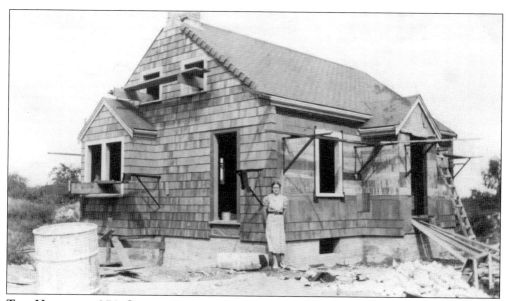

THE HOUSE AT 378 CLAPBOARDTREE STREET UNDER CONSTRUCTION, 1938. This Cape-style house was built for Helen Catherine White on the estate of her grandmother Catherine Maria Ellis White. (Susan Dyer.)

THE HOUSE AT 674 CLAPBOARDTREE STREET. This house was built *c.* 1854 by William Eddy. In 1870, Elizabeth Copeland and her sister Mrs. Washington Very lived in the house. Very's son Frank, an astronomer who worked on pioneer airplane development and radiation research, built an observatory in the yard, the base of which is still evident. (WPL.)

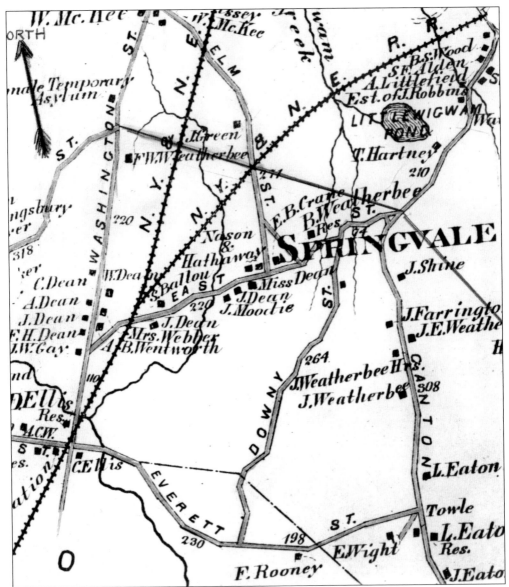

A SPRINGVALE MAP. In 1877, the village of Springvale was renamed Islington after a London borough. Judge Wentworth was one of the citizens who wanted the name changed. This map from 1866 shows the layout of the area with family names. Washington Street is visible on the map along with other landmarks. (WPL.)

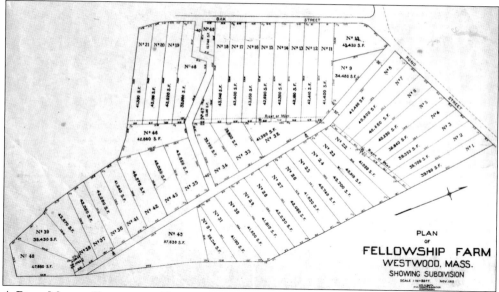

A PLOT MAP OF FELLOWSHIP FARM, 1912. Unitarian minster George E. Littlefield gathered a group of people together to form an experiment in community living called Fellowship Farm—40 acres of land on Oak Street. His motto was "An acre of land and a living." (WHS.)

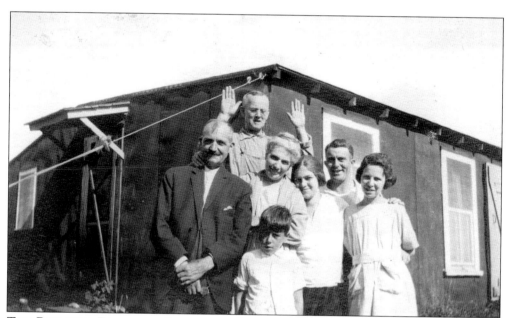

THE RAYMOND FAMILY AT FELLOWSHIP FARM, 1921. Families built one-room houses at Fellowship Farm while larger dwellings were under construction. Common property included a carriage house (used as a clubhouse), gardens, and orchards. Residents could purchase supplies at a store owned by the Hallidays. (WHS.)

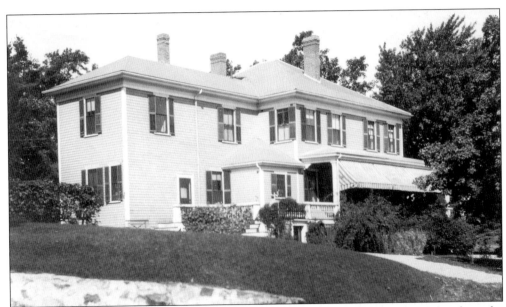

THE HOUSE AT 272 FOX HILL STREET. In the late 19th century, affluent families from the Beacon Hill section of Boston built estates in West Dedham as summer residences or took over working farms as gentlemen farmers. At one time, there was a race to see which man could finish construction on his house first. This dwelling on Fox Hill Street had a series of owners, including George A. Farlow and Emily Farlow. Other families that built houses in town during this period included the Forbes, Perkins, Rice, and Converse families. (WPL.)

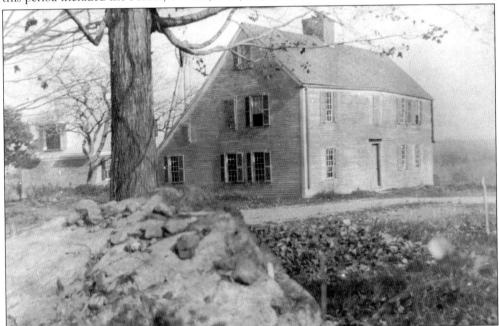

THE ABEL RICHARDS HOUSE, FOX HILL. Abel Richards served as a captain during the Revolutionary War in battles in New York and Ticonderoga. He also led men on a secret expedition in Rhode Island and served as a guard in Boston. The Richards house was torn down in the 1930s and replaced by a new house. (WHS.)

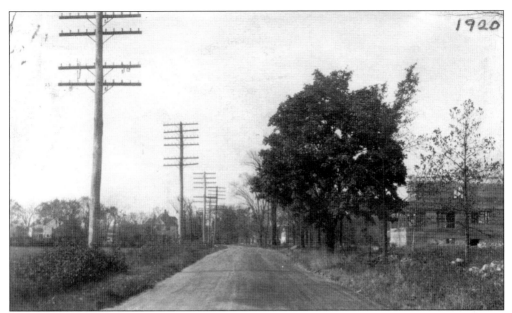

GAY STREET, 1920. This view looks west toward High Street from the corner of what is now Deerfield Avenue. Until 1872, Gay Street ran only from Islington to Fox Hill Street. Gay Street is named for the Gay family, one of the earliest settlers of the town. (WPL.)

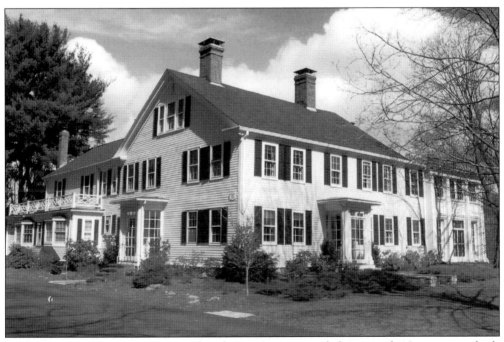

THE HOUSE AT 400 GAY STREET. This elegant Georgian-style home, with 18 rooms, was built in 1812 by Ebenezer Fisher, a prosperous farmer, legislator, and Revolutionary War veteran. In 1898, Edith Perkins Cunningham named the property Mulberry Farm after the trees planted early in the 19th century to harvest silk worms. When a devastating fire damaged the property in 1997, the current owners restored the house. (Karen Brace.)

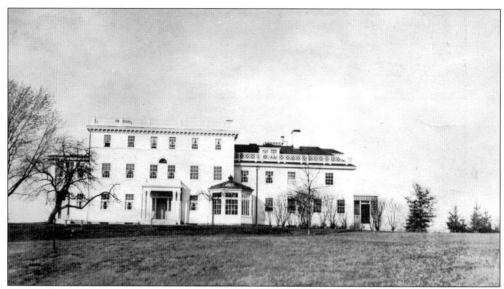

GROVE STREET. George C. Lee, an investment banker with the Lee, Higginson Company, owned this property called Hathorne Farm. The third floor was not original to the house and was added c. 1908. These photographs show the house with the additional floor and the formal gardens. (Elisha Lee.)

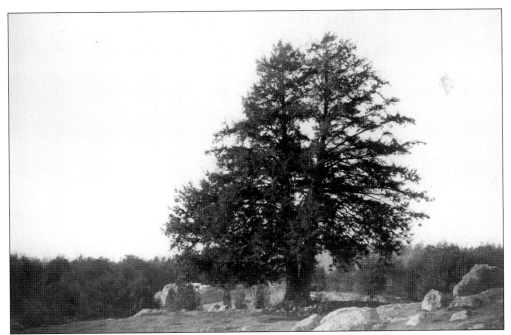

THE MOLL PITCHER TREE. This tree was named for a fortuneteller from Lynn who frequented West Dedham, and it once stood in the vicinity of High Street near Route 128. It was destroyed by storms prior to 1910. Moll Pitcher was credited with foretelling misfortune in area families. (DHS.)

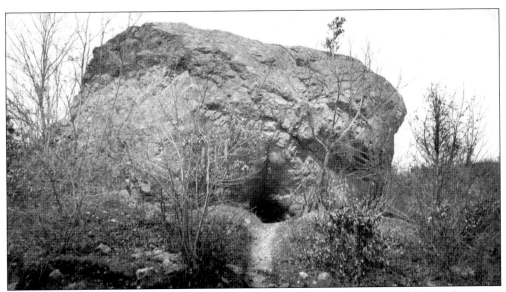

OVEN'S MOUTH. Oven's Mouth, also known as Devil's Oven, was a Native American landmark that featured a tunnel leading down into a cave. It is located on High Street near Lake Shore Drive, but street-widening projects have diminished its size. (DHS.)

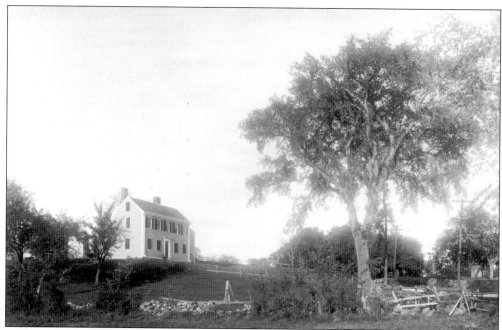

THE HOUSE AT 229 HIGH STREET, 1890. Built in the 18th century, the house was owned by the Colburn family for many years. Isaac Colburn lived here with his 12 children. In 1911, the house was moved up the hill. In 1922, additions were added to both sides and the central portion was rebuilt. (WPL.)

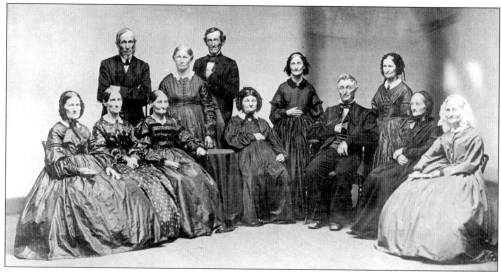

THE COLBURN FAMILY. The following is written on the back of this photograph: "Children of Isaac Colburn (1766–1845) and Elizabeth Dexter (1771–1813): Elizabeth (1789–1869) married Edward Jones; Nabby (1791–1888) married Timothy Smith; Isaacus (1793–1879) married Louisa Fisher; Polly (1795–1869) married Silas Bacon; Hezebah (1797–1895) married Nathan Everett; Sally (1797–1891) married Noah Cole; Hannah (1798–1835) married Jason Ellis; Katy 1800–1872 married Otis Farrington; Lucy (1802–1891) married Cortus B. Lincoln; John Dexter (1804–1889) married Clarissa Crebore; Julia (1806–1889) married Aolather Richards; Lyman Richards (1809–1866) married Josa Wight." (DHS.)

THE PROPERTY AT 446 HIGH STREET, HIGH AND FOX HILL STREETS. This is one of the last few standing barns in Westwood. It was added to the original property *c*. 1850 by Charles French and was used as a way station for changing horses for Post Road travelers. The house was constructed in 1768 by Jeremiah Baker Sr. before High Street extended to Dedham. (WHS.)

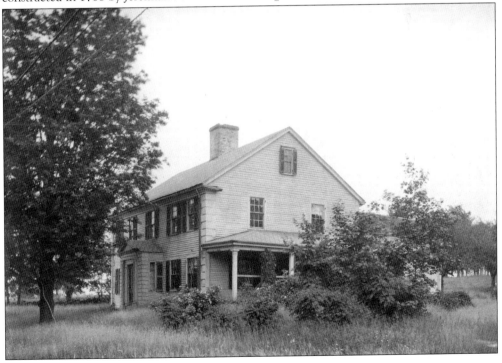

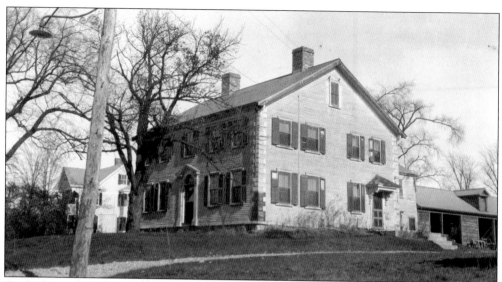

THE HOUSE AT 490 HIGH STREET, 1923. There are 13 fireplaces in this house, which was first owned by Willard Gay *c.* 1785. Ellis Gay, and later his son Erastus, ran a dry goods business here. Henry French bought the house and opened a store that sold his stove-blacking product Electric Lustre. He manufactured the product in a factory at the back of the house. (WPL.)

AN OUTBUILDING AT 600 HIGH STREET, 1920. This outbuilding was built *c.* 1820 by Capt. Leonard Mason. In the 1850s, Captain Mason and Jesse Fairbanks each owned half of the house, shop, and land. Over the years, it was a tin shop and brass foundry (owned by Mason and Fairbanks, respectively), Talbot's Oil Cloth Factory, and Colburn's Sausage Shop. Colburn's West Dedham sausages attracted buyers from the surrounding towns. The shop was demolished in the 1930s. (WPL.)

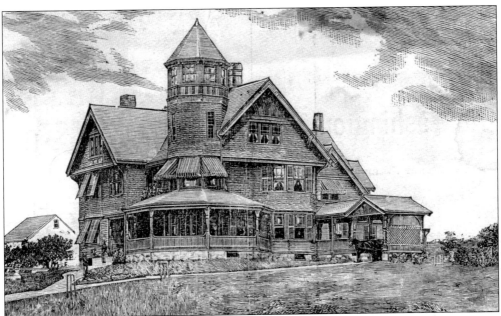

THE HOUSE AT 524 HIGH STREET. This elaborate Victorian-style house, built in 1885 for Mary Elizabeth Fisher, still stands on High Street. The land was first owned by Joseph Fisher and then by his son Joseph L. Fisher, who manufactured carriages and harnesses. When Mary Elizabeth Fisher's daughter Lady Fisher Smith would visit from England, they would hold garden parties on the lawn. The interior was decorated in the style of the late 19th century. (WHS and Gary Kellner.)

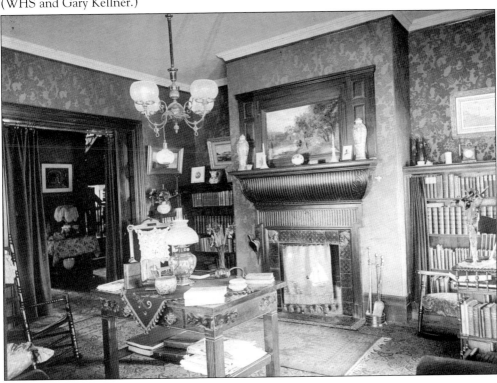

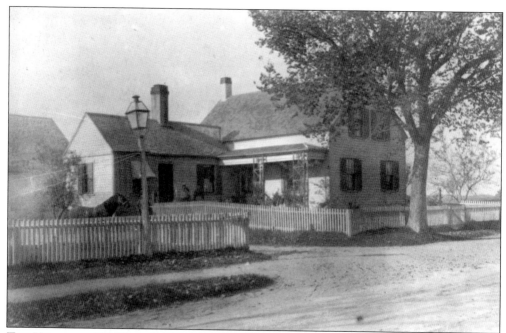

THE HOUSE AT 603 HIGH STREET, 1880. Built in 1830, this building was known as the "little Colburn house." The larger house was across the street at 610 High Street. Like many of the houses along High Street, there were businesses located here, possibly a spool factory. This house belonged to Walter Colburn and Abbott Berkeley Colburn, the town butchers. They kept a slaughterhouse in the back and a store at 600 High Street. (WPL.)

THE HOUSE AT 703–705 HIGH STREET. Located at the corner of High and Hartford Streets, this house was built by Daniel Covell in 1810. It was the first house in town to install steam heating. In 1966, the town rezoned the area from residential to business use. The Covell house was demolished in 1973, and many of the architectural features were sold as salvage. (WPL.)

HIGH STREET, 1910. This view of High Street shows the horse-drawn grocery wagon of George A. French, who ran the village store. Dr. Alexander N. Fisher's house is the first one on the left, followed by the home of Samuel Cairns at 811 High Street. Trolley tracks are to the right. (WPL.)

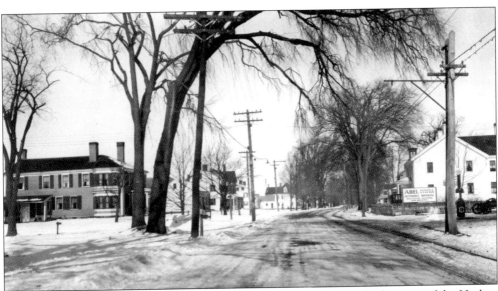

HIGH STREET, 1920. This view looks north along High Street, from the location of the Haslam Block. On the left is the Reuben Guild house (702 High Street), built in the early 19th century and torn down in 1962. On the left-hand side is the David Wiggin House (705 High Street). Henry Abel's garage is on the right. (WPL.)

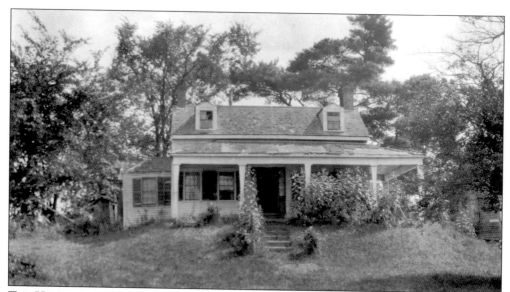

THE HOUSE AT 722 HIGH STREET, 1923. This house used to stand on the site of the present-day Gulf gas station. It was owned by Alpheus Presby in 1845, H. Presby in 1851, and J. Sheehan in 1876. The house was torn down in 1956 after a fire destroyed it. (WPL.)

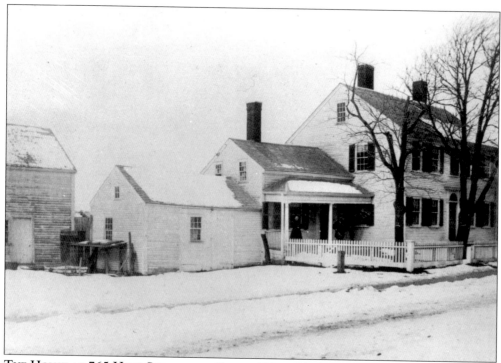

THE HOUSE AT 765 HIGH STREET, THE EARLY 1900s. Elijah Wheelock built this house, with a center hall and twin chimneys, c. 1830. Even today, the house retains its original woodwork. The ell was the summer kitchen. (WPL.)

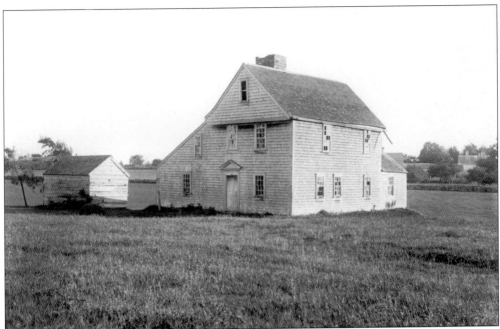

HIGH STREET NEAR PLEASANT VALLEY ROAD. Either Lt. Joseph Colburn or his son Capt. Joseph Colburn built this house in the early 1700s. Eliphalet, grandson of Captain Colburn, inherited the house. It was once described as the most photographed house in town. Although the entranceway and gateposts are still standing, the house was torn down in 1901. Pleasant Valley Road is on the site of the old farm. (WPL.)

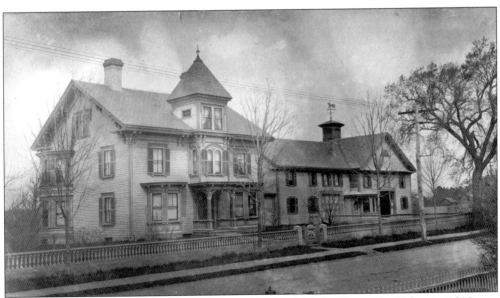

THE HOUSE AT 745 HIGH STREET. This home was built by Benjamin Fisher in 1818 as a Federal-style house and was then renovated in the Victorian style. The barn became the Haslam block of stores and offices at the junction of High and Hartford Streets. The house was demolished in December 1960. (WHS.)

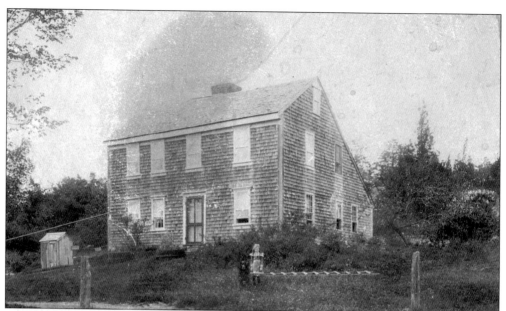

THE OLDEST HOUSE IN TOWN, 955 HIGH STREET. This house was built by Joseph Colburn c. 1680 and sold to Timothy Baker in 1770. It became known as the Baker House because five generations lived there—Timothy, Obed, Dexter, Isabella, and Ernest. Ernest Baker, town historian, restored the house and earned the 1928 Architectural Merit Award for Better Homes in America. (WPL.)

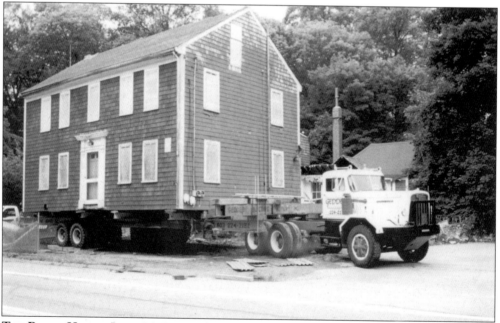

THE BAKER HOUSE, JUNE 24, 2001. The Obed Baker house was moved a half mile down High Street so that it could be restored as office space for part-time town commissioners, such as the cemetery commission, housing authority, historical commission, and veterans agency. This was made possible due to the help of many individuals, including Rep. Maryanne Lewis. (WHS and Ernie Greppin.)

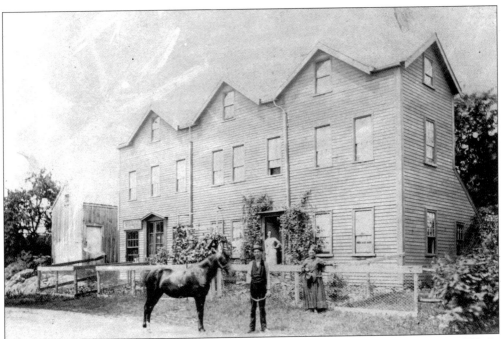

THE HOUSE AT 1297 HIGH STREET. This house has been in the same family since 1850. In the mid-19th century, it was built as a boardinghouse for Irish immigrants working in the foundry on Mill Street. The present owner's grandmother is the woman standing near the fence. (Anne Peavey Brown.)

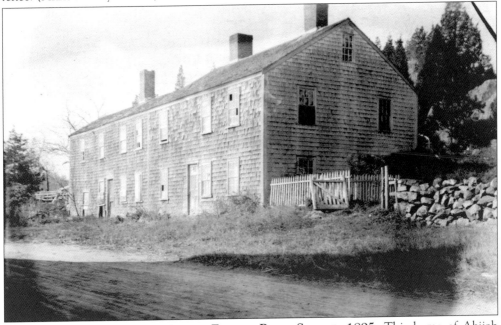

HIGH STREET OPPOSITE THE SOUTH END OF POND STREET, 1895. This home of Abijah Colburn and his daughters was rumored to have more windows than any other house in Norfolk County. It had 38 windows, 3 chimneys, and 2 front doors. Men building the trolley lines lived here in 1898. It was demolished in 1899, but the cellar walls were still visible in 1910. (WPL.)

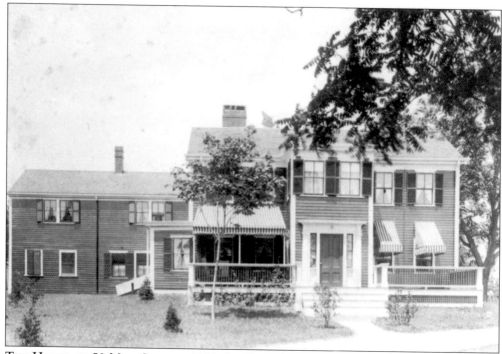

THE HOUSE AT 53 MILK STREET, 1890. In 1743, when Nathaniel Whiting and his son Isaac moved here, their friends told them they were moving back into the wilderness. This view of the house shows awnings over the windows and sitting area. There are Rufus Porter murals in the front stairway and hall of the house. (WPL.)

RUFUS PORTER'S MURALS AT 53 MILK STREET. Rufus Porter (1792–1884) and his son spent the winter of 1838–1839 in West Dedham. They painted murals in several local houses, one of which is now in the Brooklyn Museum. Rufus Porter was also an inventor and publisher. He began the weekly *Scientific American* in 1845. (WHS.)

THE HOUSE AT 68 MILK STREET. This *c.* 1855 Victorian farmhouse, with an attached barn, was originally a dairy farm owned by the Colburn family, who supplied milk to Boston and the community. Some of Westwood's present residents remember a daily trip to this farm for their fresh milk. There are many fieldstone wells on the property, one of which previously had a windmill. Hay for the cows was always grown in the field beside the house. (WPL.)

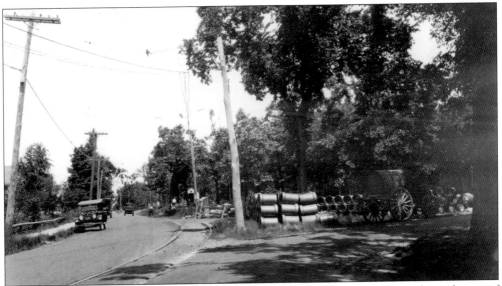

THE CORNER OF HIGH AND NAHATAN STREETS, 1923. This image shows the widening of High Street. Notice the car and pipes in the image. Trolley lines still operated on High Street at this time. At the corner was an elm tree and a plot of grass. Both were removed to widen the entrance to Nahatan Street. (WPL.)

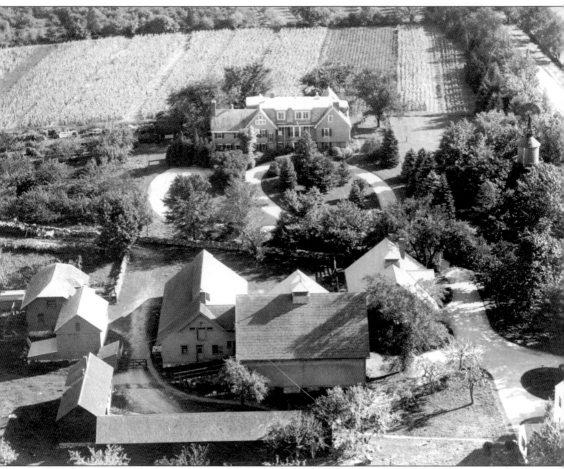

THE CROSSWAYS, 286 NAHATAN STREET. Noted composer Frederick Converse bought the Ellis Farm in 1899 and built a house with stables, a water tower, new barns, and formal gardens. While living in the house, Converse composed *The Pipe of Desire*, the first American opera performed at the Metropolitan Opera House and sung in English. Converse sold the property in 1929. (Charles Rheault.)

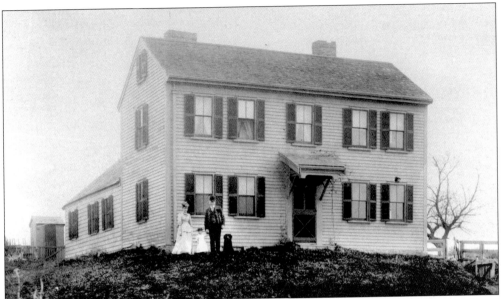

THE ONION FARM, C. 1892. At one time, this was a 40-acre farm bounded by Pond and Nahatan Streets. It was built in 1818 by Saben Baker and bought by Elihu Onion in 1845. Perry J. Crouse purchased the property for his Willow Street development. The house was torn down in 1945. (WPL.)

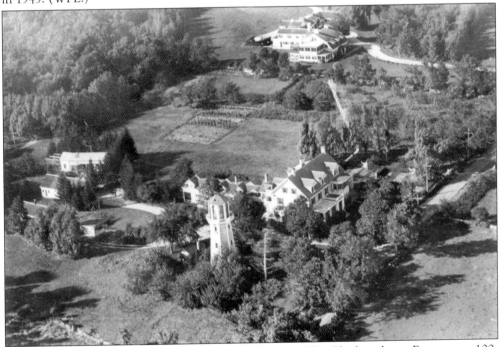

THE CLAPBOARDTREES FARM, 67 THATCHER STREET. The Clapboardtrees Farm was a 100-acre dairy farm owned by Joshua Fisher and his son Freeman. It was later owned by Nicholas Furlong, one of the proponents for making West Dedham a separate town. In 1898, he sold it to Mr. and Mrs. George Rice, who remodeled the house. This aerial view shows the house and outbuildings c. 1930, with 37 Thatcher Street in the background. (WPL.)

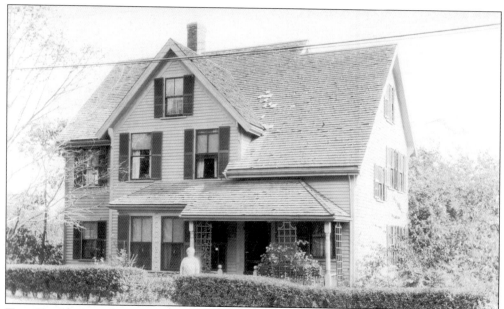

THE HOUSE AT 158 WASHINGTON STREET. This was home to the first minister of the Community Church in Islington. Frank Tolman, who worked on the Eastern Street Railway, lived here with his family until he died at age 36. Elizabeth Crane Tolman ran the E.C. Tolman store at School and Washington Streets. One of their daughters, Marion, was the last member of the family to reside here. She died in 1980. (WHS.)

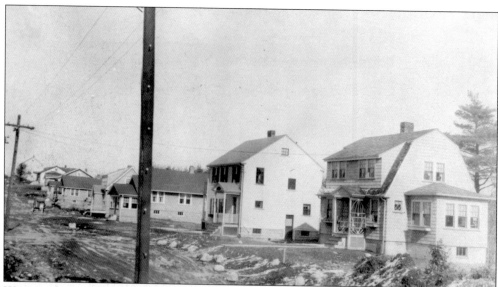

WILLOW STREET UNDER CONSTRUCTION, 1930. Perry J. Crouse, World War I veteran and manager of Dayton Realty Company, began the Willow Farm Development in 1920. It comprised more than 100 acres of pasture and woodlands bound by Pond and Nahatan Streets. Willow Street was an early part of the development. This view looks north near Reed Avenue. Many of the members of the Boston Symphony Orchestra settled in Crouse's developments around town, including the Windsor Road section. (WPL.)

Six

TRANSPORTATION

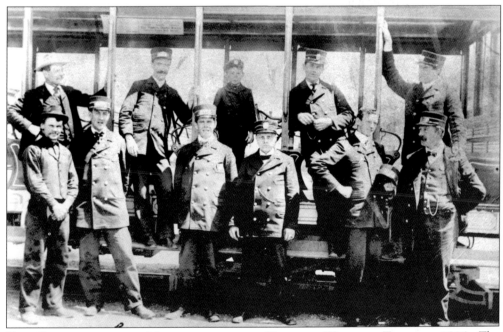

THE CONDUCTORS AND MOTORMEN OF THE NORFOLK WESTERN TROLLEY, 1910. The Norfolk Western Street Railway operated electric street railway cars from 1899 to 1932, connecting Dedham and Medfield along High Street. A carbarn in Westwood had a waiting room and restaurant for passengers. On special occasions, Japanese lanterns decorated the cars. The fare from Dedham to Westwood was 5¢. Horse-drawn carriages provided transportation along the route during snowy winters. (WPL.)

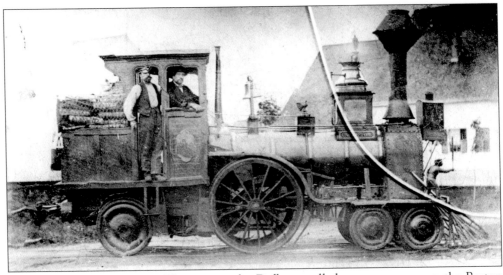

THE DEDHAM, 1856–1862. This engine, the *Dedham*, pulled a passenger car on the Boston and Providence Railroad that was chartered by the Massachusetts legislature in 1831. The engine was sold to the F & W Railroad in 1862 and renamed *Uncle Tom*. In 1867, it was sold to the Pennsylvania Railroad, pulled in two, and scrapped. (DHS.)

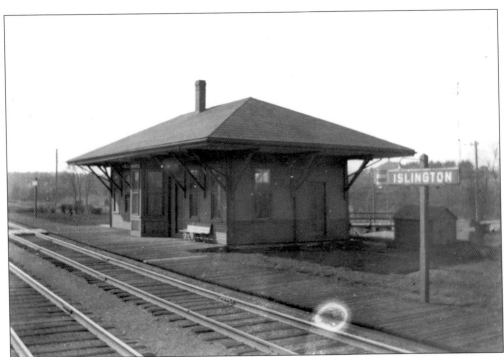

THE ISLINGTON TRAIN STATION. Originally located on Carroll Avenue, across from the present-day train shelter, the Islington station acted as both a train depot and post office from 1892 to 1917. Joseph Fietz was both stationmaster and postmaster. Mail arriving at the station was tossed off the train, while outgoing mail hung outside the station to be hooked by a passing train. The building was later rented as a residence, and it was torn down in 1951. (WHS.)

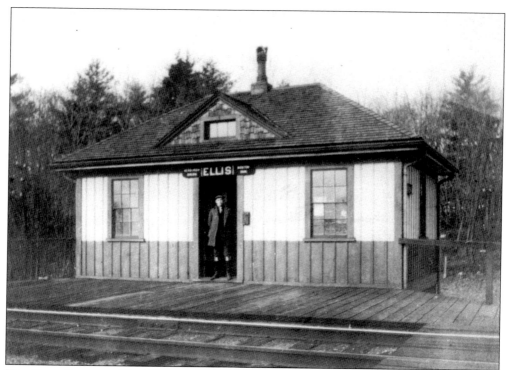

THE ELLIS STATION. The Ellis railroad station was located at the foot of Clapboardtree Street on Washington Street, on the Norwood side. Many residents rode the New York and New Haven Railroad from this station. (WHS.)

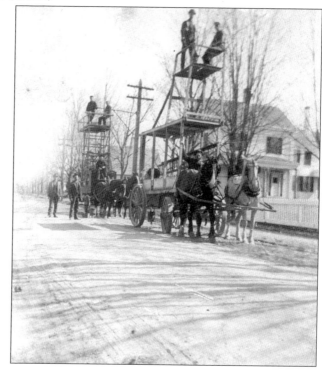

LAYING THE STREET RAILWAY. The Norfolk Western Street Railway ran electric trolley cars from Dedham to Medfield and, later, to Franklin along High Street. In order to accommodate turnouts for the trolleys, High Street had to be widened. The first cars ran on May 13, 1899, with a public celebration. There were trips every half hour from 5:30 a.m. to midnight. (WHS.)

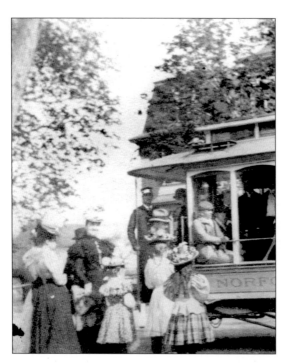

THE FEELY FAMILY GETTING ON THE TROLLEY, 1899. This image is labeled, "First car going to Dedham from Medfield. Mr. Feely in picture taken by Mrs. Feeley." People waited all day for the first cars to run. David Wiggin was the first superintendent of the line. Granville Baker's *Westwood Journal* called the cars handsome and comfortable. (WPL.)

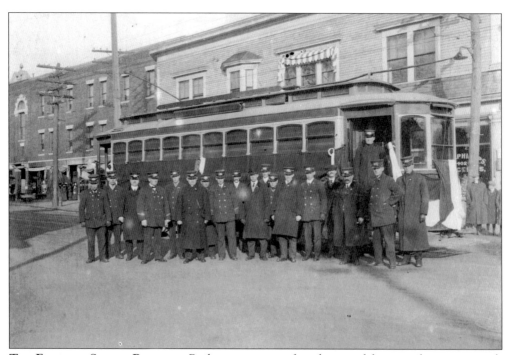

THE ELECTRIC STREET RAILWAY. Railway cars were often decorated for special occasions with Japanese lanterns or bunting. Trolleys replaced the old Fisher stagecoach, and students now took the cars to school. It cost 15¢ to travel between Westwood and Boston. The trolleys stopped running in 1924. (WPL.)

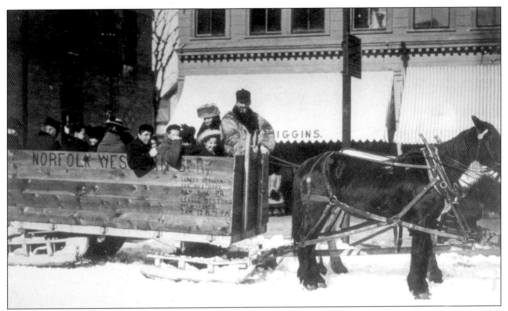

CONDUCTORS AND MOTORMEN ON THE NORFOLK AND WESTERN STREET RAILWAY. In the winter, when the snow was too deep for the regular trolley, passengers rode on open sleds pulled by horses. These sleds often substituted for the trolley during the winter months when the tracks could not be cleared. (WHS.)

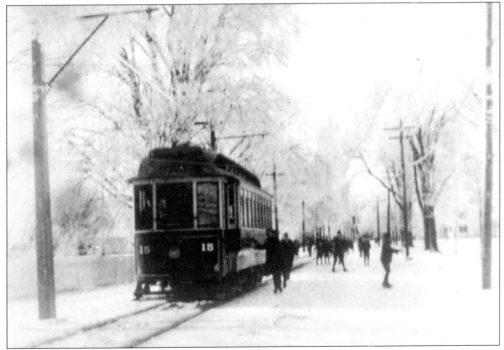

THE STREET RAILWAY. During the ice storm of 1909, the trolley line was icebound, and service halted for two months. Emergency service between Westwood and Dedham was provided by horse-drawn vehicles and sleighs. This photograph shows children skating on High Street opposite the Colburn School during the storm. (WHS.)

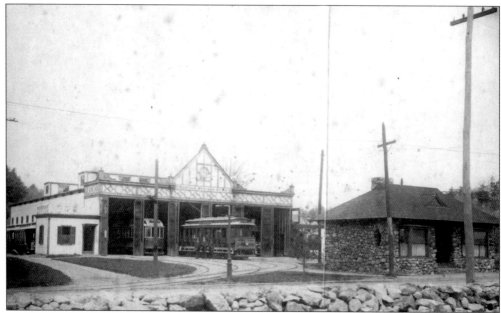

THE CARBARN. This barn was built in 1896 on High Street in the Pond Plain area. It was on the site of the present-day Sunoco station for the Norfolk Central line between Dedham and Norwood. It featured a waiting room with a telephone and a soda fountain. Westwood's citizens traveled on the trolley to make connections with other transportation. (WHS.)

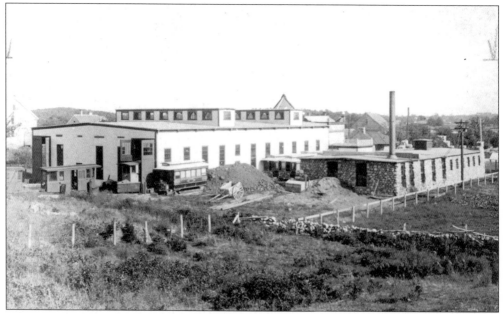

A REAR VIEW OF THE CARBARN. This barn stored the cars for the trolley line that operated from Dedham through Islington, to Norwood and East Walpole. It closed from 1901 to 1903, allowing renovations to enlarge the structure. For those two years, operations were transferred to the Gypsy Hill carbarn of the West Roxbury and Roslindale line. The line sponsored concerts in a bandstand near the barn to promote trolley travel. (WPL.)

WESTWOOD GARAGE

Telephone Dedham 790

REPAIRING, STORING, VULCANIZING

AUTO SUPPLIES

Goodyear Service Station
HIGH STREET

H. F. MYLOD E. E. WALTON

THE WESTWOOD GARAGE. Henry Mylod's garage was at the present site of the Masonic Hall on High Street. In the 1920s, Mylod ran a gas station in the attached addition at the back of the house. The barn, which was once a milk depot for deliveries to Boston, was converted into a service station. He was also the first person in town to have electricity installed. (Westwood city directory, 1917.)

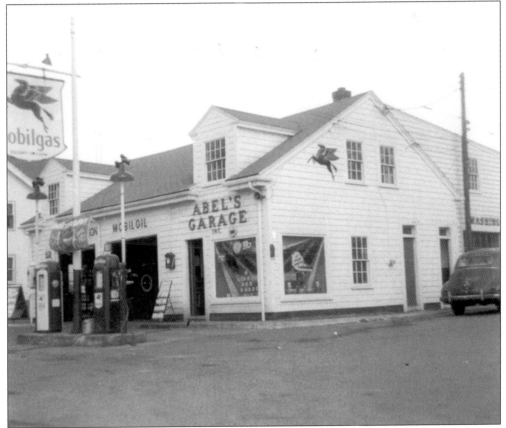

HENRY ABEL'S GARAGE, 1952. Henry Abel, son of John Abel, bought his father's blacksmith shop from Samuel Knight in 1923. He tore it down and built an automobile garage on the lot. Abel held a dance in town for the grand opening. During World War II, he would be asked to shoe horses using his father's blacksmith forge, which was still on the premises. (WHS.)

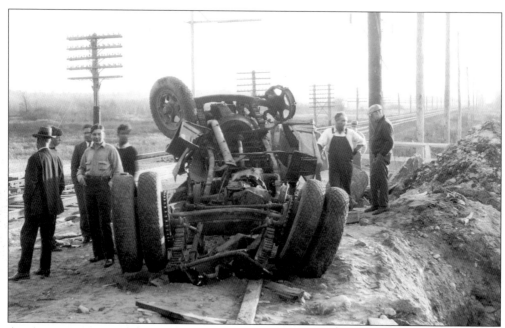

An Accident at Green Lodge Street, 1931. This photograph was taken at Green Lodge Street on November 24, 1931. A train hit a truck crossing the tracks, resulting in a fatality. During 1931, there were 58 automobile accidents, 4 of them fatal. This photograph was taken by C.L. Smith of Norwood. (Westwood Police Department.)

Alfred Magaletta, Pilot. Longtime resident Alfred Magaletta attended the Curtis Wright Aviation School. Westwood had a flying club and airport in the 1920s at the corner of High and Pond Streets. Magaletta and others taught flying, offered sightseeing trips, and did stunt flying from the Westwood Airport. After an attempt to offer airmail services, the airport closed in 1935. (Barbara Magaletta.)

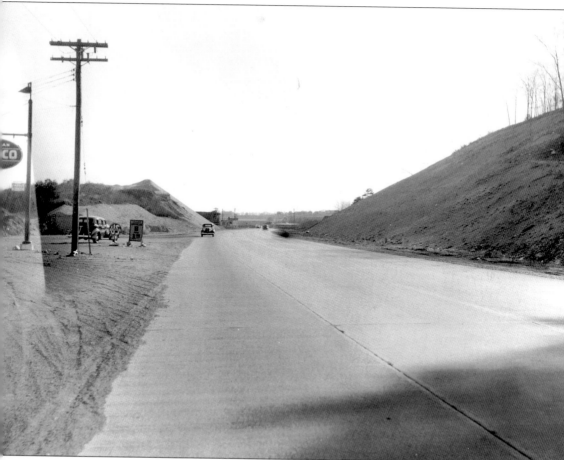

ROUTE 1, 1931. Shown here is a view of sand piles along Route 1 on February 27, 1937. The photograph was taken by C.L. Smith. Route 1 was known as the Post Road in the American colonies prior to the American Revolution and followed the present route of Washington Street. There were two roads: the middle one, which ran along High Street to Medfield, and the lower road (Post Road). Mail was delivered three times a week, and schedules could be found at taverns along the route. This was only one of the turnpikes that connected Westwood to larger cities. In 1804, the Hartford Turnpike was chartered. It followed High Street and the present-day Hartford Street. In 1806, the Norfolk and Bristol Turnpike linked Dedham to Pawtucket, Rhode Island, and along the way to New Haven, Connecticut, it ran along Washington Street. Tollgates operated along both routes, with charges varying based on the mode of transportation—foot, horse, wagon, or stagecoach. (Westwood Police Department.)

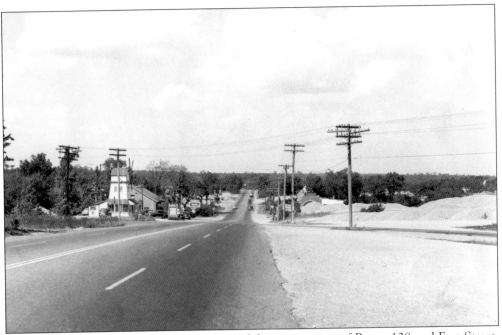

ROUTE 128, 1947. Pictured here is a view of the intersection of Route 128 and East Street. Earlier turnpikes through the town were the Hartford Turnpike (built in 1829), the Norfolk and Bristol Turnpike, and Post Road. East Street is now the site of a rotary on Route 128. (Westwood Police Department.)

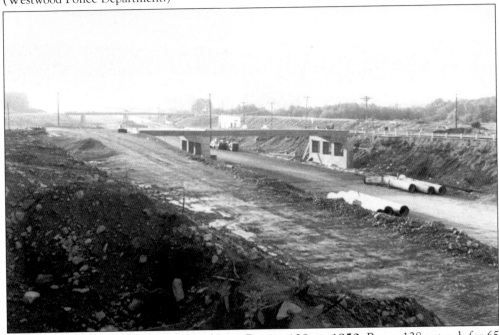

BLASTING THROUGH "YE ROCKS" TO MAKE ROUTE 128, C. 1950. Route 128 extends for 65 miles at a 12-mile radius. Two other Boston area highways were Route 495 and the Southeast Expressway (constructed in 1956). The Massachusetts Turnpike (constructed in 1963) was part of the plan to connect the ring roads. (WHS.)

Seven
TOWN LIFE

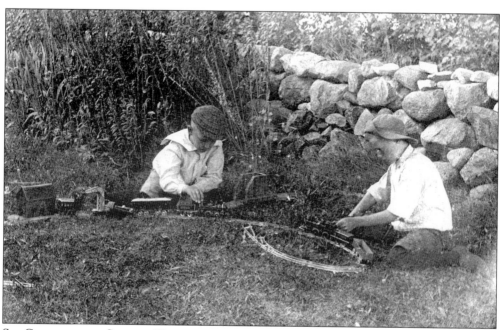

SID COLBURN AND STUART WALLACE, 1907. These two children are enjoying a lazy summer's day by playing with their toy trains. (WPL.)

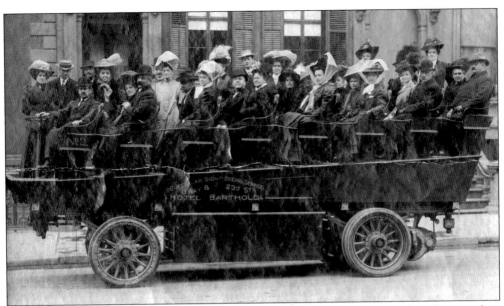

Westwood Residents on an Outing in New York City, c. 1900. This photograph is thought show the members of the Westwood Grange sightseeing in New York City. The style of the women's hats identifies the time period in which this photograph was taken. (WHS.)

One Hundredth Anniversary

of the

Westwood Post Office

1824—1924

The Westwood Grange will observe this Centennial at the Westwood Town Hall, Thursday evening, March thirteenth, at eight fifteen.

Stereopticon talk on the old Post Road, the Ellis Tavern and events connected with the establishment of the West Dedham Post Office. by Ernest J. Baker.

Reception to Postmaster Charles H. Ellis and Family

Light refreshments will be served.

YOU ARE INVITED—BRING YOUR FRIENDS

A 100th Anniversary Program. The Westwood Grange, learning that the Westwood post office would be 100 years old in February 1924, appointed a committee to plan a commemorative event. Ernest J. Baker was chosen as the chair, and he provided entertainment by showing slides of old Westwood. Copies of this presentation exist at the Westwood Historical Society and the Westwood Public Library. (WPL.)

THE PICKHART FAMILY AT ANNASQUAM, 1906. Several families from Westwood vacationed at Annasquam, including the Pickharts. The 1902 city directory lists Emil Pickhart as a traveling salesman, but he was also the author of a book of poetry, *Lilt o' the Birds*. (WHS.)

EDWARD AND SIDNEY COLBURN, 1906. These brothers were descendants of one of the earliest families in Dedham. The original settlers of Dedham had parcels of land "beyond the rocks" (in Westwood), and many eventually settled here. Many Colburns were distinguished educators. (WPL.)

WOMEN AT THE MCLAREN FARM, HIGH STREET. Anthony McLaren grew a market garden to supply produce to the Boston markets and their own farm stand. (Helen McLaren.)

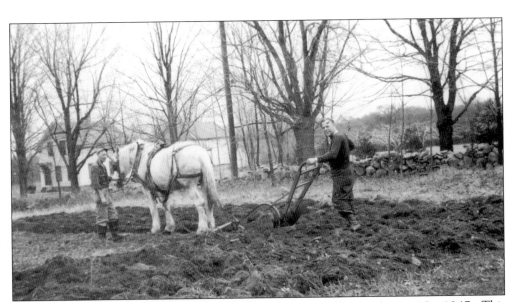

ALLAN BAIN (LEFT) AND H. WENDELL BEAL WITH A PLOW, APRIL 12, 1947. This photograph, taken in H. Wendell Beal's yard on Clapboardtree Street, shows Beal and Allan Bain preparing the vegetable garden for spring planting. The Bains and the Beals were good friends. (Susan Dyer.)

110

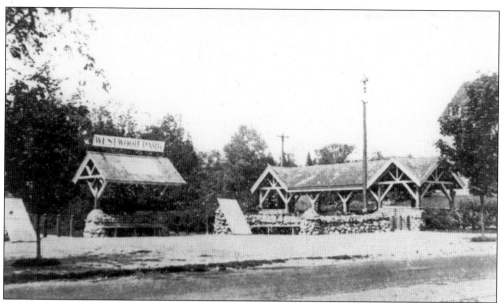

WESTWOOD PARK, 1898. Westwood Park was established in 1898 by the Norfolk Central Street Railway. The park entrance was on Brookfield Road. People from surrounding communities came to this local recreation center. There were walking trails and picnic areas in its 12 acres of woods. The park closed during World War I. (WHS.)

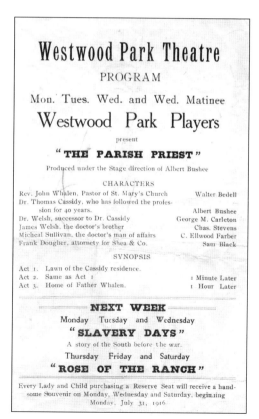

Westwood Park Theatre

PROGRAM

Mon. Tues. Wed. and Wed. Matinee

Westwood Park Players

present

"THE PARISH PRIEST"

Produced under the Stage direction of Albert Bushee

CHARACTERS

Rev. John Whalen, Pastor of St. Mary's Church — Walter Bedell
Dr. Thomas Cassidy, who has followed the profes-
sion for 40 years. — Albert Bushee
Dr. Welsh, successor to Dr. Cassidy — George M. Carleton
James Welsh, the doctor's brother — Chas. Stevens
Micheal Sullivan, the doctor's man of affairs — C. Ellwood Farber
Frank Dougher, attorney for Shea & Co. — Sam Black

SYNOPSIS

Act 1. Lawn of the Cassidy residence.
Act 2. Same as Act 1 — 1 Minute Later
Act 3. Home of Father Whalen. — 1 Hour Later

NEXT WEEK

Monday Tuesday and Wednesday

"SLAVERY DAYS"

A story of the South before the war.

Thursday Friday and Saturday

"ROSE OF THE RANCH"

Every Lady and Child purchasing a Reserve Seat will receive a hand-
some Souvenir on Monday, Wednesday and Saturday, beginning
Monday, July 31, 1916

A WESTWOOD PARK PROGRAM. Westwood Park was a first-class amusement park. Free to the public, it featured plays, vaudeville acts, carnivals, song festivals, and silent movies. Many out-of-town actors and actresses performed there. The park also had a merry-go-round and refreshment stands. Police patrolled the grounds, preventing both drinking and bicycles in the park. (WHS.)

OUT FOR A DRIVE, 1916. The majority of roads in Westwood remained unpaved in the 1920s. During the summer, roads were sprinkled or oiled to reduce the dust. Unlike today, traffic and parking problems were unknown. Roads began to be resurfaced in the 1930s under the supervision of the superintendent of streets. (WHS.)

THE TOWN SWIMMING HOLE. For many years, residents swam in the old Dedham quarry behind 100 High Street. The area also served as the town dump. The quarry is now filled in. (WPL.)

HALE RESERVATION. On April 19, 1926, Robert Sever Hale, an engineer with the Edison Electric Illuminating Company, provided land for the Dover-Westwood Scout Reservation of the Boston Council, now known as Hale Reservation. The camp was originally known as Camp Storrow, after James J. Storrow, a former president of the National Council of the Boy Scouts of America. In 1930, Hale created a new corporation at this location called Scoutland. Its purpose was to develop citizens with skills to "carry civic, moral, religious and spiritual responsibility so far as such purposes are charitable and benevolent in scope." The camp was open to both individual scouts and troops, many of whom built cabins on the reservation. When Hale died in 1941, Scoutland was renamed the Robert Sever Hale Camping Reservation. Today, Hale Reservation is the largest day camp in operation in the United States, serving more than 2,500 students each year. (Hale Reservation.)

THE EXCAVATION OF LEE'S POND, 1929. Early in 1929, George C. Lee hired local men to enlarge the millpond at his Hathorne Farm estate on Grove Street for recreational purposes. Three islands connected by cedar bridges were created from the landfill. Today, members of the Lee family still own and use this body of water. (Madeline Gregory.)

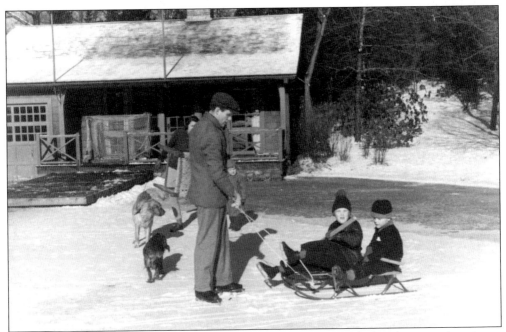

ICE-SKATING ON LEE'S POND DURING CHRISTMAS WEEK, 1934. The boathouse in this picture was built after the enlargement of the pond. The ice-skaters are James J. Lee and his children James and Emily. (Elisha Lee.)

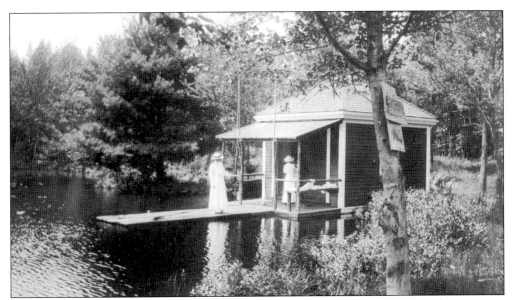

A BOATHOUSE ON LEE'S POND. While the pond was used for ice harvesting in the winter, it was the scene of many recreational activities year-round. This photograph shows the new boathouse constructed after the enlargement of the pond in 1929. (Elisha Lee.)

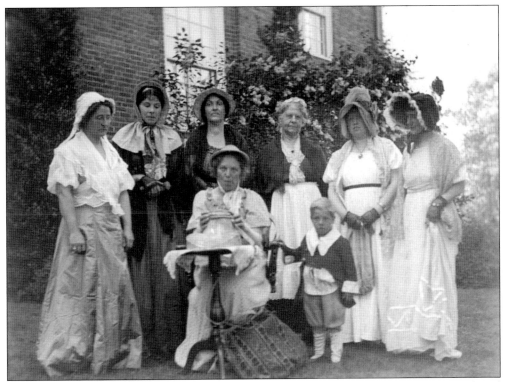

WOMEN DRESSED IN COLONIAL COSTUME, 1936. These residents are dressed in Colonial costume in honor of Dedham's 300th anniversary. Herbert Saunders is the boy standing in front. The others are unidentified. (WHS.)

The Westwood Drummer. This monthly newsletter was published during the bicentennial by J. Worth Estes, a physician and historian. It was part of a series of projects worked on by the bicentennial committee. Together with the Westwood Historical Society, a Rufus Porter mural was removed from a private home, restored, and installed in the Westwood Public Library. The *Westwood Drummer* featured articles on town events and history. (WHS.)

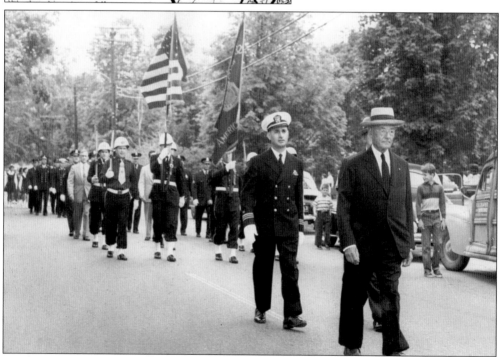

A Parade with War Veteran Alfred Magaletta. Every year, the citizens of Westwood line High Street for the annual Memorial Day parade, which features town officials, police and fire departments, and veterans. Alfred Magaletta was a well-known World War II veteran and real estate owner. (Barbara Magaletta.)

Eight
WESTWOOD
IN THE WARS

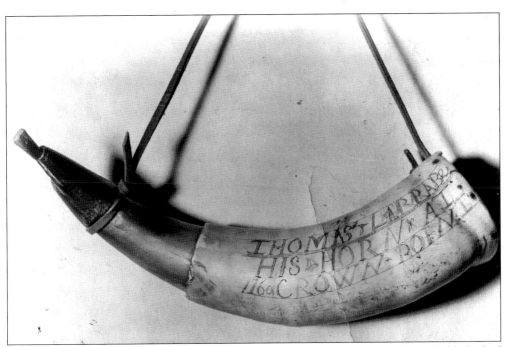

THOMAS LARRABEE'S POWDER HORN, 1760. Militia service was required of all able-bodied men over the age of 16, including one day as the designated training day. During the 17th century, a powder horn was an essential part of a soldier's arms. Like Thomas Larrabee, owners personalized their powder horns with engravings. (WHS.)

ROBERT STEELE'S HOME, HIGH STREET. Robert Steele, a West Dedham native, was only 16 when he served as a drummer boy in the Battle of Bunker Hill. His duties also included getting rum and water for the troops between assaults. When the Bunker Hill monument was dedicated, Steele played "Yankee Doodle" at the ceremony. Lydia Steele lived here until 1866. (WPL.)

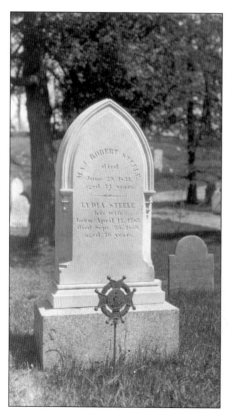

THE GRAVESTONE OF ROBERT STEELE. Steele died on June 29, 1833, and was buried in the town cemetery. Altogether, there were 69 men from West Dedham who served with the Dedham Minute Men at Bunker Hill. They were led by Daniel Fairbanks, Daniel Draper, and William Ellis. (WPL.)

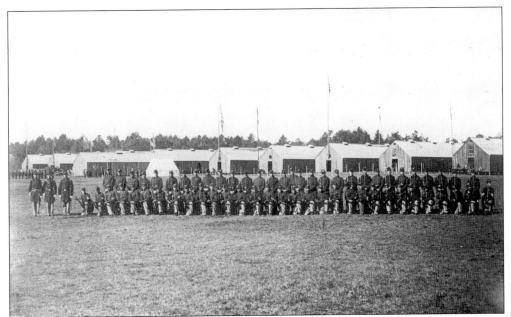

CAMP MEIGS. In 1861, West Dedham men joined Company F, 18th Regiment, for three-year terms and trained in Readville. In 1862, many young men enlisted with Company I, 35th Regiment, and Company D, 43rd Regiment. Later, in order to fill quotas, Dedham hired French and German soldiers to serve on behalf of the town. During the Civil War, 66 men from West Dedham served. (DHS.)

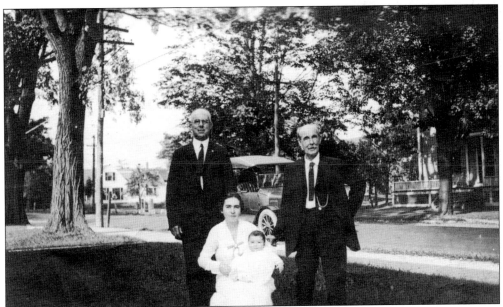

CHARLES BAKER (1841–1925). Charles Baker, a local bandsman, was one of 66 men from West Dedham who served in the Civil War. Horace Damrell, Nelson Stevens, Charles Sulkoski, and George Whiting were among the casualties. Many veterans returned to West Dedham after the war. Charles Baker's post–Civil War bandsman jacket and hat are in the collection of the Westwood Historical Society. (WPL.)

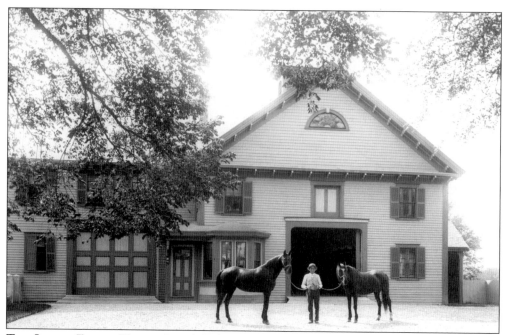

THE JOSEPH FISHER HOUSE. Joseph Fisher imported horses from the West during the Civil War. He trained and sold them at his home near the junction of High and Hartford Streets. During the war, they were sold for cavalry duty. Many private citizens also bought horses from Fisher. (WHS.)

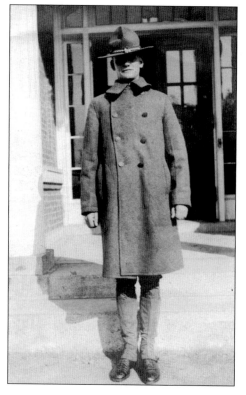

GEORGE C. LEE JR., 1918. George C. Lee Jr. attended Milton Academy and graduated with the Class of 1917. While at Milton, he served in a student unit preparing for war. His family lived at the Hathorne Farm on Grove Street. (Elisha Lee.)

PATRIOTIC
MASS MEETING
OF THE
Citizens of Dedham and Westwood

TO BE HELD IN

MEMORIAL HALL, DEDHAM
SUNDAY, APRIL 1st, 1917
AT 3.30 P. M.

MR. HENRY B. ENDICOTT of Dedham,
MR. CHARLES F. WEED, President Boston Chamber of Commerce, and
JUDGE MICHAEL J. MURRAY of Boston,
of the Committee on Public Safety, appointed by the Governor, of which Mr. Endicott is the Executive Manager, will tell of the plans of this organization and explain how Dedham and Westwood may best assist in the work.

A Special Committee, composed of citizens of Dedham and Westwood, has been organized and a report of their plans will be made at this meeting.

LADIES AND GENTLEMEN ARE URGED TO ATTEND.

GEORGE D. GIBB,	HENRY E. WEATHERBEE,
JOHN J. SMITH,	HERBERT W. BONNEY,
JOHN W. WITHINGTON,	HENRY F. MYLOD,
Selectmen of Dedham.	Selectmen of Westwood.

The Transcript Press, Incorporated, Dedham, Mass.

A PATRIOTIC MASS MEETING, APRIL 1, 1917. At a town meeting in March 1917, the citizens sent a letter to the president, urging war preparations. A patriotic meeting was held at the town hall, with prominent members of the community speaking on war programs. Seventy-nine men served with the armed forces, and five lost their lives—their names are inscribed on a marker at the town hall. Women of the town participated in the Red Cross. In 1918, the superintendent of schools reported that "the patriotic zeal of all pupils in contributing to various war funds deserves special commendation. Even the little children in the primary grades have been enthusiastic in saving pennies to help the cause." (WHS.)

GIVE ALUMINUM FOR NATIONAL DEFENSE

DONATE YOUR OLD, DISCARDED, OR UNUSED ALUMINUM FOR NATIONAL DEFENSE PURPOSES.

POTS, PANS, ROASTERS, HAIR CURLERS, WAFFLE IRON GRIDS, COFFEE POTS · · · · OF ALUMINUM · · · ARE NEEDED.

THE GOVERNMENT DOES NOT WANT ARTICLES WHICH YOU USE OR WHICH MUST BE REPLACED.

SCOUTS OR 4H CLUB MEMBERS WILL COME TO YOUR HOUSE TO COLLECT YOUR CONTRIBUTIONS.

WESTWOOD COLLECTION DAYS
JULY 25 and 26 1941

COLLECTION CENTERS AT TOWN HALL & WENTWORTH HALL

" KEEP 'EM FLYING "

WESTWOOD COLLECTION DAYS, 1941. During World War II, Westwood residents served with the Home Guard and the Red Cross. They helped conserve goods and collected materials needed for the war effort. The town's annual report for 1945 stated that 460 Westwood men and women served in the war effort, with 10 fatalities. Those names appear on the town's Gold Star Honor Roll. As the war came to an end, many organizations ceased operations. The local unit of the State Guard Reserve disbanded in May 1945, followed by the Westwood Civilian Defense, which disbanded the next month. The Westwood Rationing Board ended in September 1945, and the Westwood Salvage Committee disbanded in October of that same year. (WHS.)

HELEN CATHERINE WHITE AND HENRY WENDELL BEAL, SEPTEMBER 7, 1943. Helen Catherine White and Henry Wendell Beal worked together at the registry of deeds prior to enlisting in the armed forces. They had only three days together after the wedding before he shipped out for overseas duty. (Susan Dyer.)

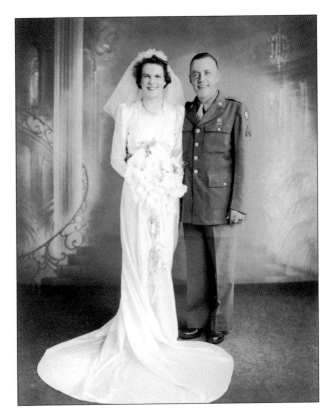

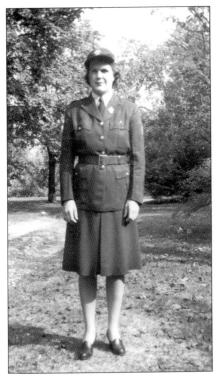

HELEN CATHERINE (WHITE) BEAL. Beal served in the Women's Defense Corps during World War II in the transportation division. She drove convoys within the United States. (Susan Dyer.)

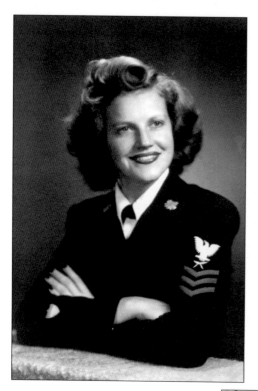

HELEN FRANCES MCMASTERS. Helen Frances McMasters, of Dedham and Westwood, was a private in the Motor Corps of Massachusetts division of the Women's Civilian Defense Corps. She served three years as a Coast Guard SPAR in the recruiting department, ending her term of service as a first-class yeoman in 1946. She and her husband, William McLaren, were members of the American Legion Post 320. (Helen McLaren.)

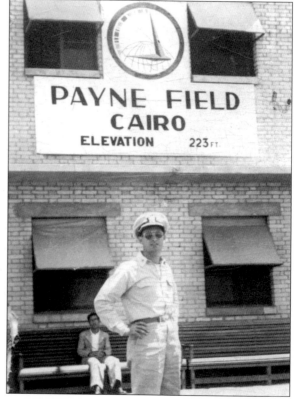

ALFRED MAGALETTA IN CAIRO, EGYPT, DURING WORLD WAR II. Born and raised in Westwood, Alfred Magaletta served as a lieutenant in the U.S. Army Air Corps from 1932 to 1935. During World War II, he was a lieutenant commander in the U.S. Navy and saw service in both Europe and Asia, receiving commendations from the navy department. (Barbara Magaletta.)

Nine

THE WESTWOOD HISTORICAL SOCIETY

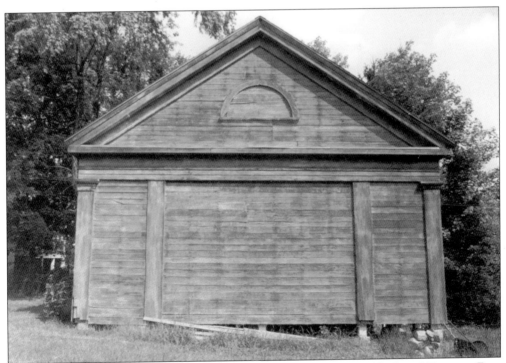

THE FISHER SCHOOL BEFORE THE MOVE. Originally located in the Clapboard Trees, or East, District of West Dedham, the Fisher School was near the corner of Clapboard and Milk Streets. It was named for Ebenezer Fisher, a distinguished legislator, farmer, and soldier. The District 9 one-room schoolhouse closed in 1905. (WHS.)

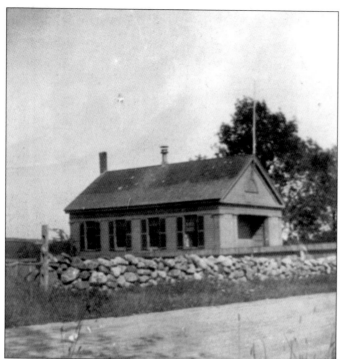

THE FISHER SCHOOL. This is an early photograph of the school in its original location at Clapboard and Milk Streets. Notice the stone wall in front of the property. (WHS.)

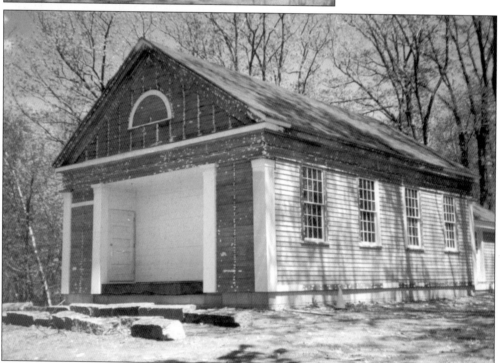

THE FISHER SCHOOL IN A NEW LOCATION. The one-room schoolhouse was donated to the Westwood Historical Society by Roger Pierce in 1994 and was moved to its present location on High Street, near the Thurston Middle School, in 1995. It now serves as the society's headquarters and is part of the Fisher School–High Street Historic District. (WHS.)

HANGING THE WALLPAPER, NOVEMBER 1999. The wallpaper in the school today is a reproduction of a wall covering made by Josiah F. Bumstead of Boston in 1845. The original wallpaper was discovered during restorations. The design consists of three Gothic arches and a decorative column. The Westwood Historical Society commissioned Waterhouse Wallhangings to reproduce and sell the paper, with the society receiving a small royalty. (WHS.)

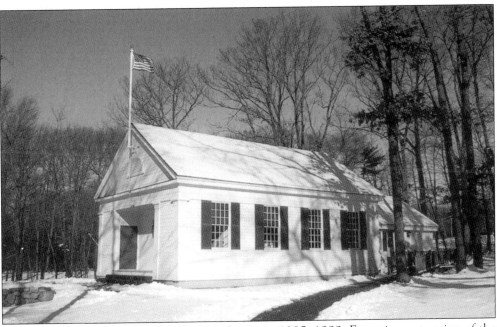

EXTERIOR RESTORATION OF THE FISHER SCHOOL, 1995–1999. Extensive restoration of the school included a new foundation, re-creating the front entrance, replacing the windows, and painting the school with its original colors from 1845. A new addition contains bathrooms and a kitchenette, with storage space for the collections in the lower level. (WHS.)

THE WESTWOOD HISTORICAL SOCIETY. The society is a nonprofit organization that promotes historical research of the town of Westwood. Among their accomplishments, they have raised more than $300,000 for the restoration of the landmark school. This photograph was taken at the celebration of the installation of the new sign donated by the Bay State Federation Savings Foundation in June 2001. From left to right are vice president Ralph Buonopane, president Lura Provost, corresponding secretary Joy Sudduth, board member Joe Clancy, board member Joan Murphy, treasurer Ernie Greppin, and past president Joan Swann. The restored Fisher School opened to the public on December 5, 1999. The schoolhouse provides an educational setting for school groups, exhibits, and cultural activities. Third-graders visit the school for an "1800s school day," where they role play the lives of 19th-century schoolchildren. (WHS.)